How To

Photograph
in
Natural Light

George Schaub

STACKPOLE
BOOKS

Published by
STACKPOLE BOOKS
5067 Ritter Road
Mechanicsburg, PA 17055
www.stackpolebooks.com

Printed in China

Cover design by Wendy A. Reynolds

Interior photos by the author unless otherwise noted

Cover photo of Red Rock country, Nevada, by Grace Schaub

10 9 8 7 6 5 4 3 2 1

First edition

Library of Congress Cataloging-in-Publication Data

Schaub, George.
 How to photograph in natural light / George Schaub.—1st ed.
 p. cm.
 ISBN 0-8117-2464-6 (alk. paper)
 1. Available light photography. I. Title.

TR590 .S35 2000
778.7′6—dc21
 00-020104

To Brynn and Emma,
and kindred spirits in light.

C O N T E N T S

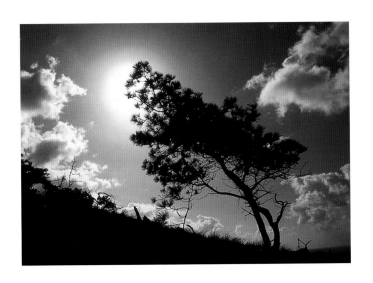

INTRODUCTION

Artists often talk about the light in certain parts of the world, such as the south of France, northern New Mexico, and numerous river valleys and mountain ranges. These regions become centers of activity for painters and photographers, and the body of work produced in them only increases their renown. That light might be clear and crystalline, as in New Mexico; infused with a special glow, like that in southern France; or diffuse and ethereal, as found on the banks of rivers or by the shores of the great oceans. These places are lit by the same sun that shines elsewhere, but there is a quality to the light and atmosphere that somehow enters the eye and reaches deep into the artistic soul.

There is a magical quality to such light, one that touches even the most hardened individual and causes a pause in the affairs of the day. Who can deny the awesome beauty of a sunset or not be touched by the mystery of a fleeting rainbow? Our delight with light in its every manifestation and form stems from our innate understanding that it is bound up with life, and with being alive.

Scientists tell us that light is both wave and particle and that our visual perception is limited to a fairly narrow band of the electromagnetic spectrum. They also inform us that it is generated by the motion of electrons and that its energy is measured in photons. Indeed, there are wonderful treatises on quantum mechanics and the nature of light written by kindly scientists who see that even laymen like me are interested enough in its poetry to sit through their diagrams and equations.

This rational approach has its charms. Being a photographer by trade, I can appreciate what it has done to help create the photographic system—the development of a way to record light onto a piece of film. This is miraculous enough for many people and is still amazing to me. At times, I have studied light like a carpenter might study wood, with an eye on practical matters and how they affected my craft. But there was always something else going on, and I suspected that I was missing some level of experience, even though it was very close at hand.

At that point, I began to question my fundamental relationship with my work. I made an attempt to slow down, to take the time to appreciate the nature of what I was doing. I made a conscious effort to sit and look—a luxury not always available—and to not take light for granted, as just a means to an end. I also began to notice that there was a body of work in my files that had no particular subject other than light and its effects. I had always approached black-and-white

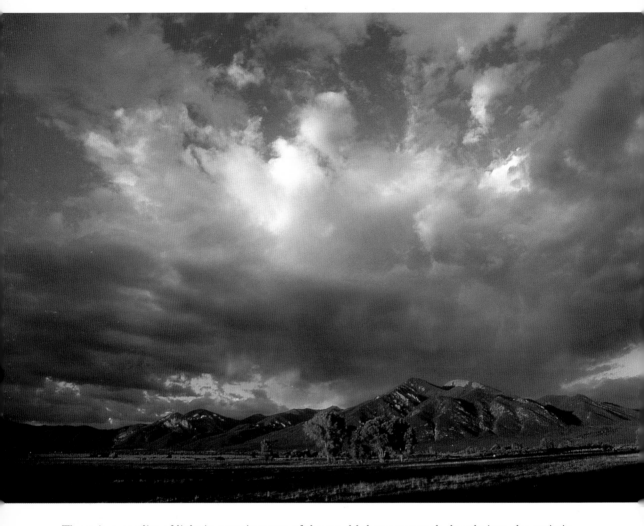

There is a quality of light in certain parts of the world that can touch deeply into the artistic temperament of the soul. That light may be hard and direct, diffuse, or tinged with a glow that graces everything it touches. To find places that speak with such power to you is a worthy task. For some, that may be in a place as spare as Antarctica, for others, one as luxurious as Maui. For me, one such place is northern New Mexico, where the clarity and warmth of the light combine with spectacular sky shows.

photography as dealing primarily with texture and tone, and there was a good deal of color work that I had placed in a folder titled "Natural Light." Something was up.

There was no ultimate conversion, no one revelation that changed the way I see.

It happened slowly, but only after I made a commitment to understand, study, and feel the light around me. It happened when I walked through the woods one fall and realized that as I passed from a shaded to a sunny spot, I left a sphere of blue to one of

gold and red; when I sat on the edge of the Rio Grande Valley and spent an afternoon watching the shadows cast by clouds move up and down the valley wall; when I read that the ancient Greeks thought that the eye sent out a visual ray that brought back an almost tactile feel of color and brightness; when I saw color as a vibration and was overwhelmed by the energy of color and light in my own backyard; when I revisited the work of Monet and Bonnard and was stunned by their intimate relationship with light.

I then remembered what an art professor in college had taught—that the Dutch Renaissance painters considered light as the word and presence of God. Each of us relates to that in his or her own way, but there's no denying that if there is something about this plane of existence that is divine—perhaps even pure—it is the light that comes down to us from above. Once it gets here and becomes mixed up in our affairs, it may be another matter. But I understand now that light as energy, as the giver of life, as the organizing principle of our vision, is a

If you are lucky enough to live in a place with vibrant light, you can take advantage of the glory at your leisure. But the energy of color and light is always around us, available at a moment's notice, if only we take the time to appreciate it. It is difficult to remain constantly aware, but there are often cues, such as a stray reflection, a startling combination of color, mist floating by the roadside. This photograph was made on a spring morning in my backyard, when color, graced by light, was popping out all over.

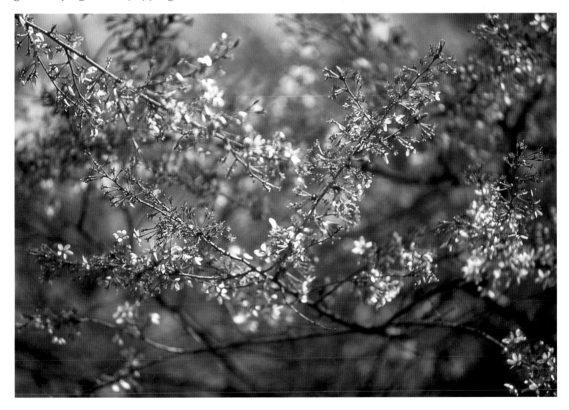

profound presence that touches and affects every aspect of our lives.

So where does photography come in? Photography is the modern visual art in which light is often the motivation for action. By definition, it is "writing with light." Just as music can make us more aware of the everyday sounds and rhythms around us, and dance can do the same with the motion of people on the street, photography is a perfect vehicle for enhancing our visual sensibilities and sensitivity. It provides us a way to instantly respond to and eventually give back those moments that express an appreciation of light's glory. As a vehicle, it can be used to get you where you want to go. It need not be an exercise in production—it can be a tool for opening up and seeing. As I have worked more consciously, I have become convinced that photographers who engage in an appreciation of light will get so much more out of what they do, and that even people who do not consider themselves "photographers" can use a camera to open up their visual senses.

This book, then, is about perception and application. It attempts to address moments that reveal the nature of light for its own sake and as a motive for making pictures. It works with the proposition that photography is a path to awareness that can be used to open our eyes to the world around us. It is a how-to book in that it deals with practical matters of exposure, film, and filters and all that goes into making effective renditions of what we see. But it's also intended as a meditation on light, on how an appreciation of it can change the way we see. It's a circular notion, a reinforcement of one aspect with the other.

This book is also a qualified consideration of light and photography in that it deals with natural light—that generated by the sun rather than via a charged filament or the controlled explosion we call flash. This eliminates discussion of photography using artificial light, not because of any prejudice against it, but because natural light takes us outdoors. If you're like me, we've both spent too much time inside.

I'm always mindful that our first impression of someone or something we see is the light that the person or thing reflects into our eyes. It is a primary sense that creates our impression of and relationship with people and the world around us. When we photograph, we are engaging in a process that captures a kernel of perception, a seed that can grow to open our and others' eyes. It is hoped that this book will contribute to that process, and that it will serve as a small reminder of the potential each moment holds.

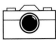

Natural Light:
The Light and the Shadows

The pond is still, like a mirror that splits the world in two. Above and below are equal, as a trick of the light doubles the color, light, and design. A bird flies over, and its reflection follows suit. As if stirred by that flight, a soft wind begins to drift through the valley. The mirror becomes disturbed. The real remains stolid save for a slight bend to the boughs. The water gains texture and design, following the pattern of the waves. The sun drops lower in the sky, and from where you sit, there's a coincidence of light. The dance of light begins on the water—the pond glints and dazzles as the reflection of the sun flits from crest to crest. The intensity of the light obscures detail, and you see only light and shadow. Clouds pass before the sun, and you are back in the land of bark and boulders, pond and sky. The edges of the harsh shadows soften, but only long enough for you to adjust your gaze. The clouds part, and all becomes silhouette again. As the sun sets below the horizon, it lights up the sky, and the pond takes on the color of that sky and is all rosy red and purple. As the wind quiets, you again see the reflection of the sky on the surface of the pond, but this time it's a single glow, a coming together of color, light, and design. The circle of life meets itself at dusk, to await the parting again at dawn.

Any consideration of natural light begins with observation. That observation can occur at any time and place. You consider subjects and follow the path of light back to the sky.

The source of all natural light is the sun. All subsequent light is derived from that of the sun and draws its intensity from above. The ancient Greeks mythologized the sun as Helios, riding a chariot through the sky and shooting sunbeams in the form of arrows toward the earth. Aside from being a lovely allusion, the myth tells us that light from the sun heads toward the earth in a straight line. But living under a layer of protective atmosphere and surrounded by objects that interplay with that light, you are more often dealing with light that is reflected, refracted, diffused, or otherwise changed by this world.

If you are sitting on the beach on a summer day, you might expect that the sun's rays are hitting you directly from above. They are, but you are also subject to the light and heat of the sun reflected off the sand, from the water, and even from the cooler that awaits opening on the blanket beside you. That light may be diffused by the mist that lies offshore and is refracted when you stand in the water and look at your feet beneath its surface.

In an open field at high noon, you might expect even lighting on the things around you, whether the overall illumination is

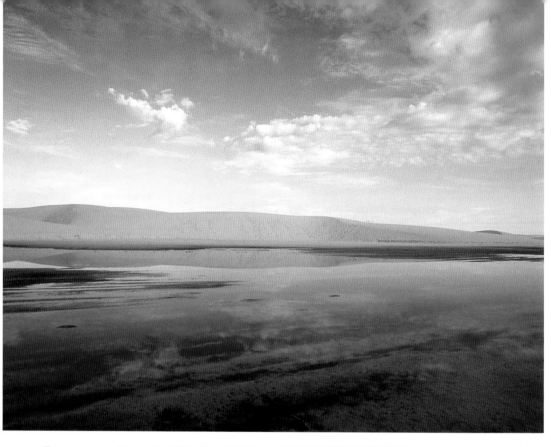

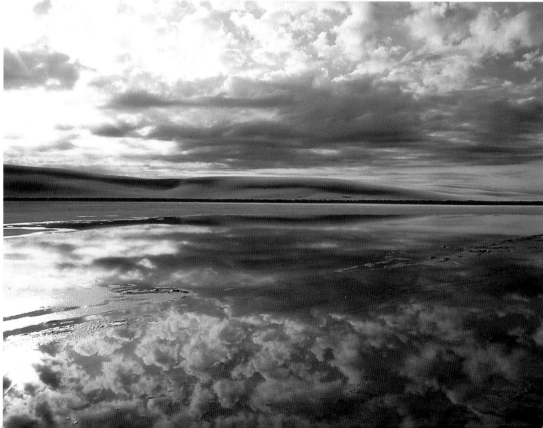

bright (under a cloudless sky) or dim (on an overcast day.) Yet when you look around that field, you see light and dark objects, their shadows, and the subtle differentiation between things that are lit by the same light.

You'll soon discover that what began as straight rays of light have become shaped by the world and its objects. The brightness, or luminance, of the world we inhabit is a matter of both the overall lighting condition and the subjects or objects it illuminates. Light is dynamic and ever-changing, and its subtle and sometimes apparent effects are what allow us to differentiate the objects in this world. In short, it is what helps us make our way through life.

If you have ever been in a severe blizzard, you understand what it would be like without this power to discriminate. When white-out conditions occur, the ground and sky become one, a disorienting experience to say the least. This can also occur when a low fog hangs offshore and you cannot make out the horizon line. You have no way to orient yourself and no sense of perspective or scale to guide you. If you have ever driven through thick fog, you know that there is no way to make out scale or to easily grasp the speed at which you're traveling.

Normally we do not have to contend with such conditions, however. We make distinctions between objects in part based upon

Light shifts and changes throughout the day as the angle of the sun and atmospheric conditions change. There are no two moments alike, no two days exactly the same. Observation is the key to appreciation, and patience is rewarded by a constantly changing display. These two photographs were taken two hours apart from the same vantage point in White Sands National Monument in southeastern New Mexico. An approaching storm changed the color, mood, exposure, and content of the scene.

the intensity of light they absorb and reflect. Thus in an open field you can see the difference between a dark rock and blades of grass and between the tufts of seeds on a dandelion and the surrounding forest. On the beach, you can see the color and form of your cooler and distinguish the lid from the box so that you can reach inside for a cool drink.

The relative brightness values, or different light levels, in our world are actually two joined phenomena: the level of illumination of the source light and the degree of reflection, transmission, and absorption of the things it reveals. One balances and always plays with the other. This coupling also affects color and the relationship of one object to another. These considerations are of more than just academic or even fanciful interest; they are quite important when making photographs and attempting to creatively render those brightness values on film.

The Prime Source

Although the prime source of light is the sun, and the sun is up there every day, we do not describe every day as sunny. We usually describe source light levels, or degrees of brightness. We use such terms as bright, dim, or dull, or meteorological references to the ambient conditions, such as open sky, overcast, stormy, or cloudy. We also relate to the light source based on seasonal conditions: Summer in the South may be hazy; winter in northern New England may yield a hard, brisk light. The direction and angle of light also affects our perception: In winter, the sun sits lower in the sky, as it does later in the day at any time of year. Point of view—where we stand or sit when we look at a scene—also has a profound effect on our perception of the character and substance of light.

In short, there are hundreds of conditions that affect the way the source light reaches us and how we subsequently

describe it. Those influences include where and when it reaches us and through what atmospheric conditions it passes. All this forms our subjective assessment of the levels of brightness.

The variety of lighting effects reaching us is infinite. This variety stems not only from the myriad of factors that affect light's path, but also from the fact that people see or "read" the light differently according to their culture, position on the planet, or personal disposition. This leads to one conclusion:

Every moment is unique.

That is, our perception of natural light is undergoing constant change. True, the sun rises in the east and sets in the west. But after that, it's all up for grabs. If you take the time to observe, you will see this to be true.

Observation requires patience, not something in great supply today, as our attention spans grow ever shorter. We human beings seem to abhor change and seek the relative security of consistency. But sit on the edge of a canyon, with clouds streaking overhead, and watch the changes on the opposite wall. Shadow and light are undergoing constant interplay. What was bright and open moments before, the next minute is deeply shrouded. Sit there every day at the same time, and you'll never see the same show. Sit there every moment, and no time of day will have the same pattern and design.

Granted that every moment is unique, it becomes obvious that it's important to pay attention to what's going on around you.

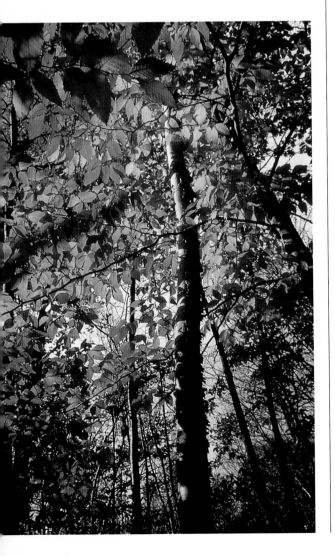

One light descends from above on everything—that of the sun. Our ability to discriminate among things is based on the variety of effects that light undergoes as it is absorbed, reflected, and transmitted through, into, and around those things. Those effects influence the color and brightness values of this world and play with one another to form images and associations in our minds. This photo of fall foliage shows a wide variety of lighting effects; the color and shade of the leaves vary depending on the angle of light striking them and the degree to which they absorb, reflect, and transmit light. The bark of the tree ranges from bright white to deep black. The overall brilliance of the scene is determined by the atmospheric conditions in the sky; a cloudy day would result in a much different rendition.

Light Defined

The difference in source light on an overcast and cloudless day is obvious. Light levels, or luminance values, are greater when there's not a cloud in the sky. We can refer to that difference as that between a point source of light, where there are bright highlights and distinct shadows, and diffuse light, when shadows lose their hard edges and there is a more gradual transition of tones. The character of light is often revealed by the edges formed on shadows.

On an overcast day, the clouds themselves can be thought of as the light source, as they act as a sort of giant diffusion panel in the sky. Professional studio photographers understand the difference between a point source (outdoors, the sun on a clear day; indoors, direct light from a flash) and a diffused source (outdoors, a cloudy day; in the studio, a flash fired through a softbox). Under diffuse conditions, the light strikes a scene from many different angles. A point source behaves the way it sounds, striking

When light is overly diffuse, we lose edges, scale, and perspective and thus the power to discriminate. These ethereal moments remind us how much we depend on shadows, contrast, and line to orient ourselves in the world. Here, a low fog hangs off the shore of the Long Island Sound, obscuring the horizon line where the water begins and the sky ends.

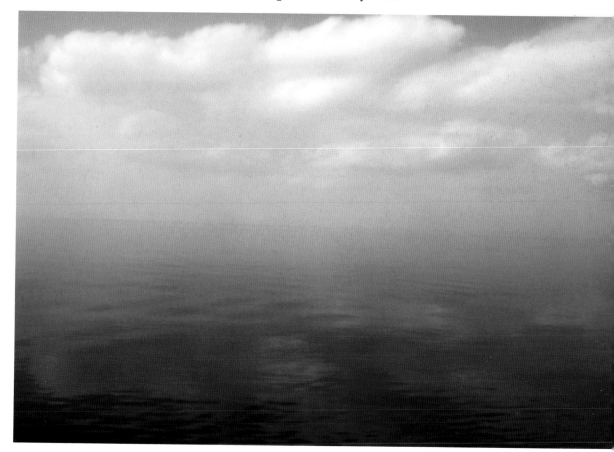

the subject from just one same angle. The degree of diffusion determines the range of tones, or visual variety, and helps characterize the boundary between the brighter and darker parts of the scene. Most professional photographers prefer diffuse light because of the way it affects the color, contrast, and tonal values. When making the translation from observed to recorded light on film, the softer light is much easier to control.

Atmospheric Influences

Aside from the obvious difference between a cloudy and a sunny day, there are a number of other atmospheric and directional influences on the quality of natural light. These include altitude, temperature, location, and seasonal influences. Being aware of their effects can lead you to photograph in certain places and at certain times.

The light above 10,000 feet is quite different from that in which most of us live. There is less atmospheric haze, and the "cleaner," harder light can dazzle the eye. Such light often shines above the tree line. I have seen it in the high eastern Sierra in Schulman Grove, home of the ancient bristlecone pines. The first thing that strikes the eye is that the ground is brighter than the sky—the opposite of the usual relationship. The next thing you notice, when looking down from above, is the haze shrouding the lower elevations. Below 8,000 feet, the light tends to be more diffuse, though wind conditions may temporarily disperse the haze to let through clear light from above.

Another striking thing at high altitudes is the depth of the blue in the sky, a result of the light not being dispersed and diffused by atmospheric haze. Those of us who are flatlanders or city dwellers are often left momentarily breathless.

The temperature and relative humidity of the air also have a profound effect on the

character and quality of light. When the air is laden with moisture, and temperature differences between the air and ground are just right, fog begins to form. The fog belts in the eastern Appalachians and the Sacramento River Valley, with its famous Tule fog in winter, are prime areas to find this effect.

Warmer air tends to soften light. When extremely hot air rises from the ground, we get those mysterious mirages, products of rarefied air that causes light rays to bend in intriguing ways. Subjects are raised and reflected in the air, distorted in various ways. Indeed, the thirsty traveler roaming the desert often spies an oasis that is nothing more than a reflection of the clear sky elevated by the waves of heat rising from the surface.

The moisture level of the air also has a profound effect on that most glorious of atmospheric displays—the rainbow. The best time for rainbow chasing is right after a good afternoon storm, when the sky begins to clear and the sun moves closer to the horizon. Rainbows are formed by light playing on the fine mist and scattered drops of water that are remnants of the storm.

The time of year also affects the quality of light. Winter light tends to be clearer and harder than summer light. This is due in part to the temperature and relative humidity of the air and the "cleaning" winds from the north. It is also affected by the angle from which the sun's rays reach us. The clarity of winter's light can be startling.

The light at the shore—be it a riverbank or an ocean beach—tends to be unique. It is strongly influenced by the different temperatures and currents this ecological border creates. Head to the shore of a lake, stream, or river at dawn or dusk, and the quality of light playing on the body of water will generally be different from the light in which you stand.

Times of transition are fruitful for photographers. A river photographed at dawn,

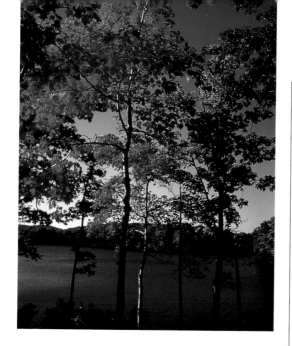

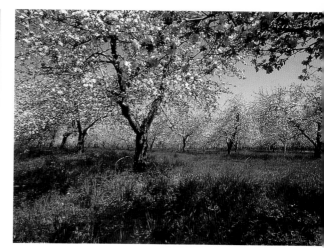

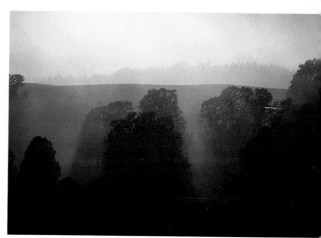

The character of light is influenced by many factors. Seasonal changes afford some of the most obvious differences. Because geographical location will determine how the light plays, traveling to spots where this play of light is most evident will have great rewards. In the spring, the light is luxurious. It is filled with the moisture of showers and made dazzling by the ever-warming sun. Color emerges from its winter slumber and reminds us that life was not absent, just waiting. This blooming orchard (top right) was photographed in New York's Catskill Mountains in May. Summer air is thick with mist. Haze forms after passing showers and drifts around the mountains and valleys. The scene at right was photographed in Vermont's Green Mountains after an August afternoon downpour.

Autumn offers the best of both worlds—the crisp light of chilly afternoons and dazzling color. This intense red foliage (above) was photographed in Harriman Park, New York, not far from the Hudson River Valley. Winter can be overcast and dreary, but it can also offer the crispest light of the year. Here (bottom right), in Kings Canyon National Park in California, the brightness of the snow provides reflected fill to "open up" the shadows.

SUMMER PHOTO BY GRACE SCHAUB

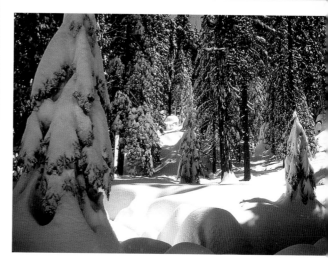

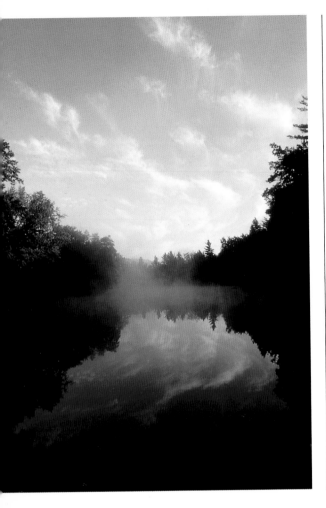

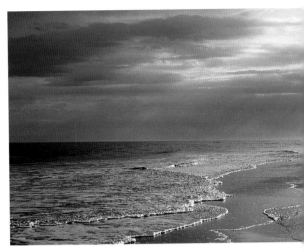

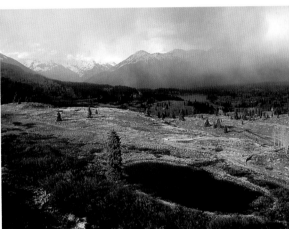

The light at the border of land and water undergoes constant change throughout the day. In the morning, mists begin to move along the Housatonic River (above left) in Massachusetts, held in mysterious borders along its banks. The sun has just broken the horizon, touching the tree on the left. The river serves as a mirror of the light above.

As the day wanes and the sun begins to move toward the horizon, these quiet waves (top right) at Jones Beach State Park on Long Island pick up every highlight and color in the sky.

A similar transitional area occurs at the edge of a storm front, when shafts of light and rolling clouds combine to create a potential for wonderful photographs. This storm (bottom right) was just clearing from the mountains outside Durango, Colorado. LEFT AND TOP RIGHT PHOTOS BY GRACE SCHAUB

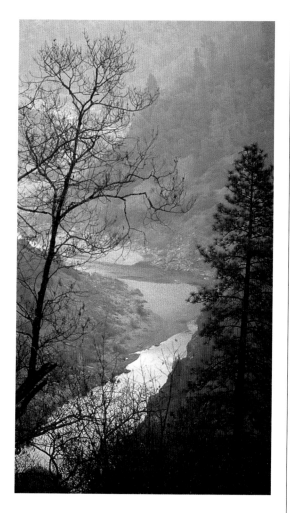

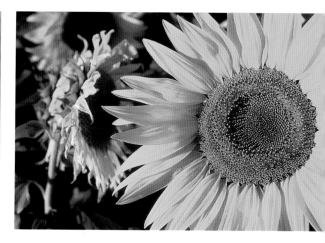

The difference between a point source—direct light from the sun on a clear day—and diffused light, which travels through cloud cover or haze, is apparent. This sunflower photographed outside Arles, France, shows the etched-edge sharpness and color vibrancy characteristic of point-source illumination. Conversely, the American River valley outside Auburn, California, is bathed in the soft, purplish light of a late afternoon. The light from the setting sun travels through the mists that rise from the valley. Contrast, color rendition, and shadow formation are quite different under the two lighting conditions.

when mists rise and edges blur, is usually more interesting than at high noon. And, the best landscape photographs are often made at times of approaching or clearing storms.

Point of View

Light in and of itself is invisible. The light that descends from above is made real by its interaction with the objects it strikes. Whether you photograph ethereal clouds or a brilliant aspen tree at the height of its fall foliage, you are always dealing with the interaction of light and matter. This interaction requires the perception of the observer. In photography, this is defined as the point of view and refers to that place or stance in which we receive the message of light as well as the mental readiness or openness to see it.

Point of view has everything to do with the effect of light coming from a certain direction. Light direction determines where the highlights—the brighter parts of the scene or picture—and shadows will fall. It is what creates the illusion of depth and gives a sense of presence to a subject or scene.

Light direction is defined from the point of view of the photographer or observer. Frontlighting hits the subject from the direction of the photographer. It is "over-

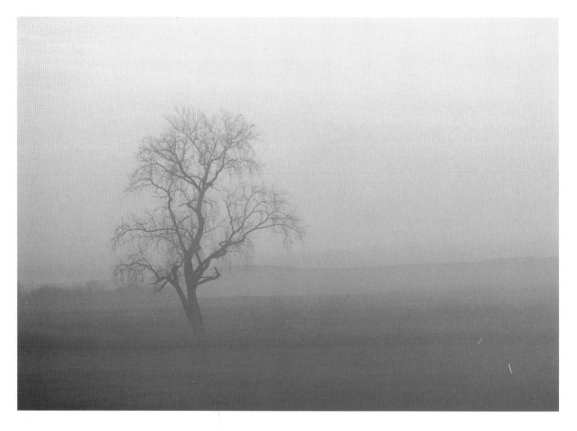

Humidity has a profound effect on lighting conditions. Fog and rainbows are the most dramatic effects. Here, the Tule fog in the Sacramento River Valley in California isolates a tree in a perspectiveless plane, giving only a hint of the rolling land in the background.

the-shoulder" light, the scenario often prescribed by camera and film manufacturers as the least problematic. Shadows—a key part of creating the illusion of depth in a photo—fall behind the subject. For that reason, it's also called flat light.

Backlighting strikes the subject from behind. A subject that is strongly backlit is often recorded as a silhouette. There is only form, and no detail within the form, although the background area is well exposed. Backlit photographs can be quite dramatic. The silhouette can serve as a reinforcement or symbol or to frame the scene. Let's say you're photographing a

canyon and sky and want to use a foreground subject for both scale and visual relief. Which would be better for that foreground silhouette: a large boulder or a gnarled tree? Both would provide a break from the visual leap to infinity, but the tree will reinforce the character and sense of place, whereas the boulder might just provide negative space.

Backlighting can also be used to good effect when the subject you are photographing transmits light, such as autumn foliage. I relate to translucent, backlit subjects as if they are stained glass windows in a church. Viewed from the outside, the windows are

interesting, but viewed from the inside, they show their full glory. As the light hits the window—or leaves—depending upon the surface and the angle at which the light hits it, some of the light is reflected; some is absorbed, resulting in unique colors; and some passes through.

Sidelighting, or directional lighting, strikes a subject from an angle other than directly from the front or back. It occurs in the late afternoon, when the sun is lower on the horizon, and in the winter throughout a good portion of the day. Sidelighting is a wonderful light in which to photograph. It is great for enhancing surface texture and for granting a sense of three-dimensionality of a subject on film. The play of surface texture and sidelight highlights the difference between the rough bark of oak and the satin skin of birch, the grit of sandstone and the hard-glass surface of obsidian, and the placid and the storm-tossed sea. Whatever the subject, the visually tactile character of its texture is always enhanced by directional lighting.

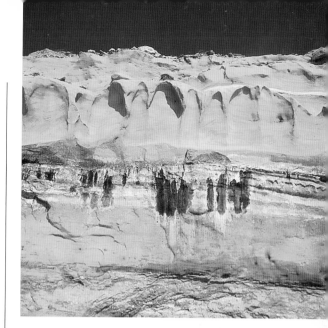

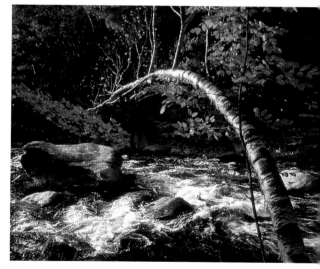

Frontlighting is generally considered flat light and offers the least exposure challenge, but just because it's less challenging doesn't mean it has to be dull. This photograph (top right) of a cliff at Torrey Pines beach north of San Diego, California, shows that frontlight needn't be flat or dull.

The most dramatic sidelighting is when the light comes from a right angle—perpendicular to the subject as seen from camera position. Here (middle right), outside Newfane, Vermont, the light seems to be coming downriver as it strikes the edge of the tree and places hints of color in and around the river.

Backlighting is quite dramatic, especially when there's potential for light transmission and silhouetted forms. These aspen (bottom right) on the Williams Lake Trail north of Taos, New Mexico, glow in the late-afternoon light.

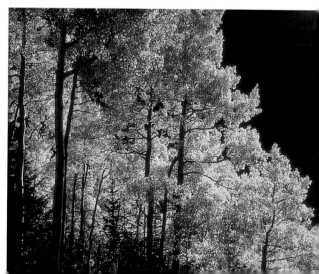

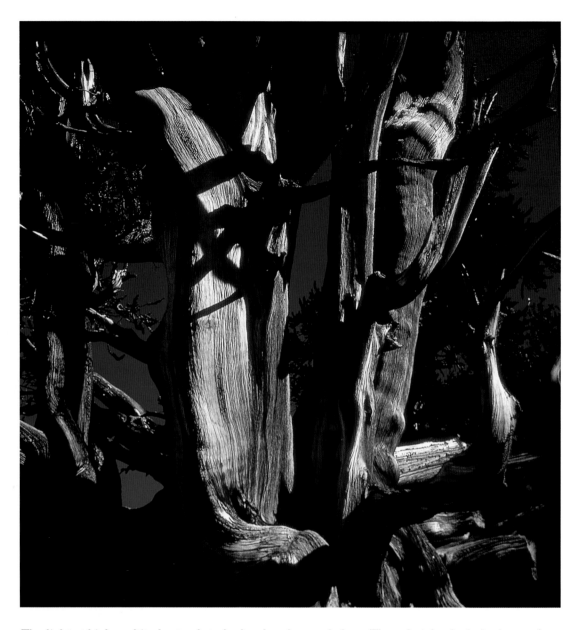

The light at higher altitudes tends to be hard and crystal clear. These heights lack the haze of lower elevations, and the light is less scattered in the thinner atmosphere. At Bristlecone Pine National Monument in California, the contrast produced by that light is intense, as are the reflections off the bark of the bristlecone pines. An exposure that holds textural detail in the bark causes deep shadows and a very deep blue sky.

Photograph the bark of a tree with frontlighting and then with sidelighting, and the differences will be apparent.

Texture can be shiny, flat, pebbled or stippled, grainy, and so forth. Given some surface relief, texture offers the possibility of inherent shadows (shadows cast by the subject onto itself), thus even greater dimensional rendition. Texture also affects the reflection of light from the surface and the brightness value of the subject itself. A calm sea reflects light like a mirror; a rough sea throws off spectral highlights—glints of light that play off the rise and fall of the water—that become enhanced against the darker background.

There's also something we could call toplighting, where the sun is directly overhead, as occurs in midsummer. This is perhaps the most difficult condition for good photographs. Enjoy the day, but don't spend too much time taking photographs.

The Power of Reflections

Reflection is the light that bounces off a subject. It is what allows us to discriminate between one object and another. Almost nothing—save some phosphorescent deep-sea creatures—generates its own light. What we see is based upon what is reflected from subjects around us. How we perceive the reflection depends on the angle at

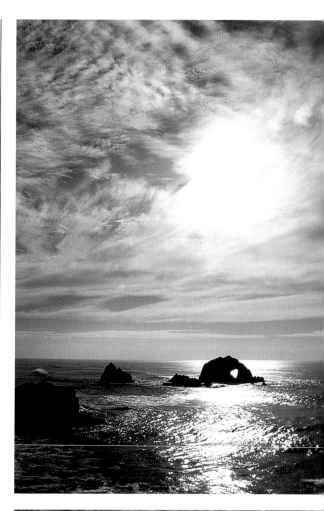

The point of view of the photographer—on a cliff (top right) on San Francisco's Seal Rock—combines with the height of the sun over the horizon to create this reflection. Alter the position of the sun or the photographer, and the nature and position of a reflection will change.

The same is true of this fall reflection in a forest pond (bottom right). Walk a pace to the left or right, or move back a foot, and the way you see the entire scene will change.

PHOTO BY GRACE SCHAUB

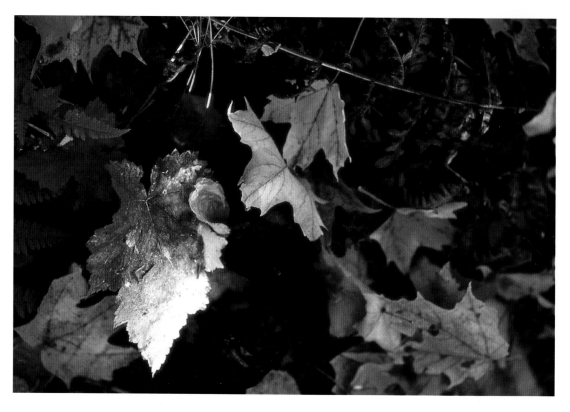

These autumn leaves display different colors, and the surrounding forest floor different bright-
ness values, from light to dark, because of the way the light is absorbed and reflected. Here,
a touch of frost is kissed by the light at the edge of a leaf, making for a very bright reflection.
Change the point of view, the angle of the sun, or even the slight bend in the leaf, and every-
thing about this photograph would change. What we see here as red or green and what we
perceive as light and dark are our impressions of the interplay of absorption and reflection.

which we look at it and the angle of the light striking it. This leads to a law that is important in photography: The angle of incidence (the angle from which the light strikes the subject) equals the angle of reflection.

You can see how this works by observing the surface of water from several different angles. Wait until the sun is fairly low in the sky, and stand at the edge of the water. Now sit down at the edge. Then walk 20 feet back and to the right or left. Each change in your angle of view will change the quality and degree of reflection. Along your route, you

might see direct reflections. These are called specular highlights and are mirror images of the light source itself.

As this experiment shows, the angle of reflection is greatly influenced by your point of view. If, for example, you are photographing a stream under the dappled light of a tree canopy, certain parts of the water will be in sunlight and others will be in relative darkness. If the reflection is to your liking—that is, if it serves to add a spark to the scene—then photograph away. If not, simply walk around the stream and

consider it from various angles of view. This will allow you to place the spectral highlights wherever you desire in the frame. You might also notice that changing position tends to have more effect on a dark object than a light one.

Reflection is light bouncing off a surface. The texture of that surface and the degree of absorption of the subject will determine just how much light is reflected. When the surface is very shiny and the angle of reflection and viewpoint combine to create glare, the luminance value, or brightness, will exceed that of other parts of the subject or scene. This can easily be seen when the wind is blowing through the trees. As the wind tosses the leaves, they catch the light from different angles. As the angle of incidence (where the light catches the leaves) equals the angle of reflection (how the light bounces off the leaves), the moving leaves kick off different intensities of light. It's quite a show.

Reflection works hand in hand with absorption. Most objects absorb part of the light that strikes them. The degree of this effect has a profound influence on our perception of both the relative brightness of a subject—how light or dark it is in the context of the scene—and its color. Light that is fully absorbed appears black. As some things absorb different frequencies of light than others, they appear red, green, blue, or some combination of the primaries. White light contains all colors. An object appears to have a certain color because it absorbs certain parts of the spectrum and transmits and reflects others. In a sense, it has no inherent color, but because of absorption, reflection, and transmission, we see it as having a certain color.

Absorption is also closely allied with texture. Think of two different textural surfaces: the dark bark of a tree and brightly lit snow. The bark absorbs most of the light, reflecting very little, while the white snow splashes it all back into the eye of the viewer. In some cases, such as the glistening snow, the subject seems to act as a light intensifier that concentrates and boosts the value of the brightness it receives. In short, what we see is a result of the reflection, absorption, and transmission of the light that strikes the subject. If it's translucent, it will absorb some of the light, transmit the color and a slightly lower light energy than it caught, and reflect some of the light from its surface. That's why quaking aspen is such a visual delight. It's the three-ring circus of light play—absorption, reflection, and transmission all going full steam simultaneously.

Your point of view is the key to it all. That's why consideration of the light before making photographs is essential. Move around and see how your point of view yields different light effects. One position may yield predominantly reflective light and another predominantly transmitted light. Many photographs are affected by the quality and direction of light and how that combination enhances color and texture. Although subject matter is at the core of any effective photograph, how it's lit can make all the difference in the world.

Shadows

The brightness and direction of light have another important effect: the quality and depth of shadows. Shadows help define shape, scale, and tonal relationships. They can serve as a visual echo or a distortion, depending upon the angle and intensity of light that strikes the form. They have a depth, or a degree of light and dark, and on close inspection are rarely as uniform in density as you might think. Shadows have rims and indentations, edge glows, and color.

The photographic illusion of the black shadow is more a matter of the film's inability to record the very wide range of brightness values, from deep black to bright white, that can be perceived by the eye

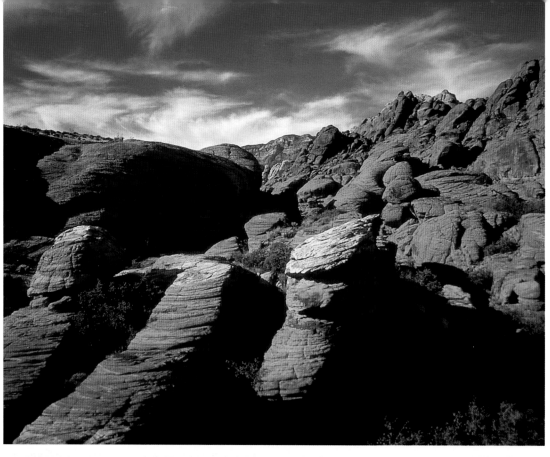

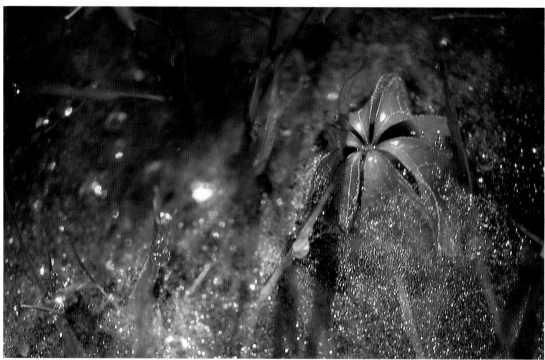

than of the shadow's actual depth and color in nature. In short, shadows are elusive. They are more than dark areas that create so-called negative space in the frame.

The overall brightness level has a profound effect on the nature of shadows. When light is bright and crisp, shadows have a more defined edge than when the light is diffuse. Shadows exist on overcast days, given a certain level of brightness, although they certainly are less pronounced than when the sun is shining brightly. Shadows are also context dependent—their depth and color can be changed by the color of the subject itself, its degree of opacity, and the light reflecting from other subjects in the scene. A shadow slightly filled with reflective light can reveal details that add much to a photograph.

The overall brightness level affects the depth of shadows and our ability to capture details within the shadows on film. In photography, significant shadow refers to the darkest area in the scene in which you want to—or can—record detail. When pho-

Shadows play an important role in defining content and form and in creating a sense of dimension and scale in photographs. The depth and color of shadows recorded on film depends on overall scene contrast and the way the exposures are made. These two photographs show the difference between an open, or textural, shadow and one in which detail is sacrificed to serve more graphic ends. The deep shadows at Red Rock outside Las Vegas are created by strongly directional late-afternoon light. They form the borders that define both the rocks in the foreground and the strata in the more distant formations.

A softer shadow is formed by the light as it is diffused through misty spiderwebs on the ground. The spectral highlights formed by the dew catching the light at an angle add to the background fill light. PHOTO BY GRACE SCHAUB

tographing scenes that contain both subjects and their shadows, the higher the contrast, the greater the difficulty. In some cases you may be forced to concede to that purely photographic phenomenon: the black shadow.

Shadows help create depth and dimension in photographs. Photography is a two-dimensional medium. Our use of depth-of-field techniques, perspective effects with different focal-length lenses, and exposures to simulate dimensionality all go toward overcoming the flat picture plane. As you work with light, consider the shadow as another ally. When shadows are deep, see them as graphic exclamation points that can accentuate form, scale, and perspective.

Contrast

One of the major concerns in photography is contrast, the perceived difference between the lightest and darkest parts of a scene. If you work in a photographic studio, you do everything you can to limit contrast so that you record as full a range of tonal values as possible. Outdoors, you have much less control.

Contrast is related to brightness levels, but even when the overall level of illumination is bright, you still may be working under a normal or even low-contrast lighting condition. For example, we would all consider bright sun in the desert a high-brightness situation. If all the subjects within your frame were close to an equal brightness level, however, that scene would be, in a photographic context, fairly low in contrast. If you were to introduce a low-reflectance, highly absorptive subject, such as a dark rock, into that frame, you would quickly change that low-contrast scene into one with high contrast. This is important to be aware of when considering how to handle contrast and the way subjects will record on film. Contrast is highly dependent on how subjects absorb, reflect, and

 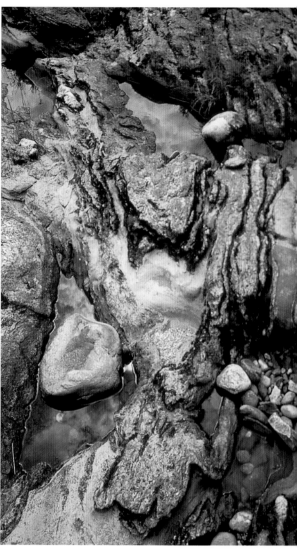

Scene contrast is highly dependent on the subject—its surface and, to an extent, its color—and, especially, on the photographer's point of view. Though we might assume that a sunny day always provides more contrast, in photography that occurs only when the subjects in the frame reflect and absorb different brightness values themselves. This scene (above left), near Ghost Ranch in New Mexico, was photographed on a very bright day. The subject is frontlit, and the metered value hardly changed when the meter was moved from the desert floor to the sky. Though it's bright to the eye, to the camera it's a low- to medium-contrast scene.

This streambed (above right) near Newfane, Vermont, was photographed under an overcast sky. The light was dull but allowed us to catch every textural detail. This is a low-contrast scene, as the meter did not budge when moved throughout the frame.

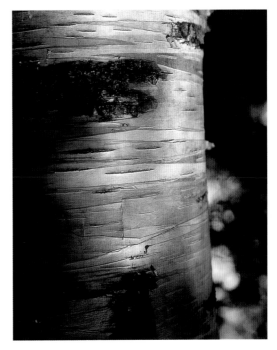

At right, the birch bark caught directional light, and the reflection caused it to be quite a bit brighter than the background. The photographer chose to expose for the highlight in order to retain texture in the bark. This caused the background to record much darker than it appeared to the eye. Thus the tree trunk and the background make for a high-contrast mix.

Conversely, the photograph below was exposed for the background light to retain texture in the leaves, and all detail has been lost in the tree trunk. Low contrast allows you to capture most of the scene details, whereas high contrast may force you to make decisions about what will and will not record with detail on film. TOP PHOTO BY GRACE SCHAUB

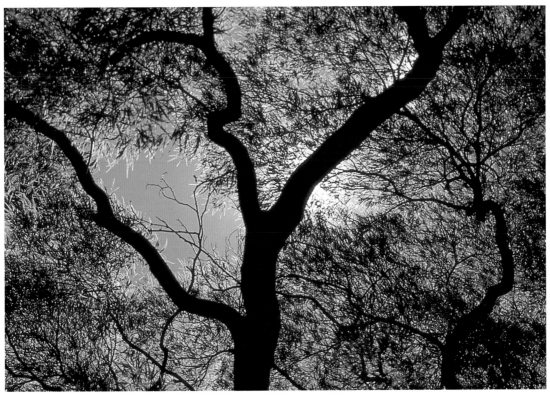

transmit light. The proportion of these aspects in every scene affects the overall contrast.

The degree of diffusion of the light source—for example, a sunny versus an overcast day—has a profound effect on the contrast of the scene. Direct light creates higher contrast, whereas more diffuse light transforms the scene into a lower-contrast one. High-contrast scenes tend to be more graphic and articulated, and lower-contrast scenes tend to be more detail rich, although too-low contrast caused by extremely dim light may lose color richness, thus diminishing the overall impact of a scene. Black-and-white photography diminishes this effect somewhat, as color richness does not enter into play. You can also boost or lower the contrast of the scene by extending or decreasing the recommended developing time of black-and-white film.

Contrast becomes greater if you include the light source in the scene, be it the point source of bright sun or the diffused source of an overcast sky. If you photograph a vista that includes the sky and one excluding the sky, the former will generally have more contrast than the latter. The photograph need not include the actual light source itself; indeed, including the sun in the frame of any photograph will make for a very high-contrast scene and difficult lighting conditions. The only time you should consider including the sun is when it is very low in the sky, it is diffused by mist or clouds, or you want to play with silhouettes.

Understanding scene contrast effects allows you to tackle problems that otherwise could get in the way of making a good photograph. High-contrast scenes are more challenging, but they often allow you to reap great rewards.

Atmosphere: Weather Conditions and Natural Light

For natural-light photographers, the dance between land and sky is the canvas that creates the variety and the possibilities for our work. While we accept certain conditions as inherent to a specific season and glory in the transitions between those seasons, it's the day-to-day changes in weather that create the most possibilities. These changes are the moods and emotions of nature that we all attempt to capture on film.

Pollution

If you're reading this now, we can assume that the millennium passed without the oft-predicted Armageddon. But those of us who have been on the planet for any length of time have observed that there are other forces at work that, though far less dramatic, are, in the end, probably just as destructive.

When our great cities are part of future strata and the cult of mass production becomes a fanciful treatise for some future archeologist, there may be some recognition that our endless cycle of consumption is what finally did us in. That cult is largely responsible for the increasing amount of haze that shrouds the planet—the blanket of dust, smoke, and smog that no amount of wind seems to relieve.

You can see this haze from about 5,000 feet and down. It's apparent to airline passengers and from those at high vantage points, such as the slopes of any big mountain. There's no question that it's been getting worse over the years, and not just in the usual urban disaster areas like Los Angeles, New York, Kuala Lumpur, Mexico City, and Hong Kong. Las Vegas is a prime example. In the middle of the last century, you could drive out to Red Rock Canyon or to any height and see clear across the valley. From the Strip or downtown, you could clearly differentiate the colors in the surrounding hills. Now, on most days, you can see neither. As the number of buildings, roads, and cars increase, the clarity is almost completely gone. Indeed, there are even days when you can't see the mountains from the Strip. And the Grand Canyon is becoming shrouded by a coal-burning plant hundreds of miles away; the dust and smog of overbuilding is stretching the circle of pollution more and more toward the center of the wilderness.

All this is to say that as photographers, we have many fewer of those crystal-clear days in which to work. Pollution makes distances less distinct and casts a generally blue light—or even worse, sometimes a yellow haze—over every long-distance landscape we attempt to get on film.

The photographer can approach this in two ways. One is to accept the condition and just record what's there. The other is to try to do everything you can to eliminate it.

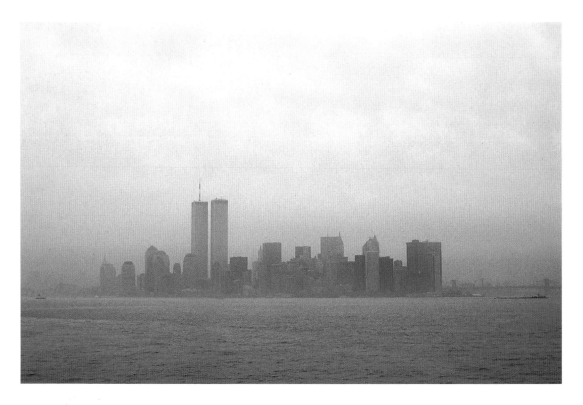

The greatest influence on light these days is pollution. The haze from soot and smoke not only covers our major cities but has crept deep into wilderness areas as well. No UV filter will remove this haze. It may reduce it slightly, as there is some ultraviolet component in that light, but it will have no effect on the soot and dust particles themselves. The gunk absorbs light and can look brown, yellow, or dirty blue. Here, downtown New York City floats in its own muck.

You can sidestep the problem if you wait until a good, stiff wind cleans the stuff out of your point of view. You can photograph very early in the day, because cooler air tends to be crisper and there's less dust from human activities. You can also work late in the day, when the sun is lower in the sky and casts an amber glow that at least counteracts some of the bluishness and brings the illusion of golden health to the scene. During the day, you can use a slight warming filter for blue haze or a light blue filter when the yellowish cast is prevalent.

There are times, however, when you don't have the chance to eliminate the haze. It then becomes a matter of a personal decision. The idealists among us will probably wait the condition out, knowing that a smog-filled landscape won't sell many calendar shots. A blue mood can be pleasant; it's just that indistinct, flat, vague light of pollution that seems so depressing. But let's face it—haze and pollution are now facts of life.

Some folks think that an ultraviolet (UV) or skylight 1A filter will do the trick. These filters do act on the blue in a distant landscape that results from aerial perspective; they do not, however, filter out smog, smoke, or dust. They remove whatever UV

component is in the mix but can't eliminate the light scatter and diffusion caused by dust and smog.

Aerial Perspective

When we view things that are far away, we are looking through a thicker layer of air. As distance increases, those subjects appear to be covered more and more by a blue veil. This phenomenon is called aerial perspective—the effect of light scatter over distance—and has always been used by landscape painters as a way to indicate distance and scale. As landscape photographers, we might rightly ask just how much of that blue we really want to eliminate. That mellow blend of distant blue with foreground clarity is what helps give perspective to landscapes. This naturally occurring phenomenon helps us define near as distinct and rich with color and far as soft and a deeper, cool blue. And there are times when aerial perspective can lend a beautiful transition and sense of space to scenes.

That doesn't mean, however, that UV or skylight 1A filters—the most common way to correct for aerial perspective—should never be used. There are times when the distant blue should be tamed, especially when there is no foreground visual relief or

Aerial perspective is a factor in virtually all landscape work, especially when a long line of sight is involved. A UV or skylight 1A filter can help reduce its effects, although it can be left unfiltered when a sense of scale and perspective is desired. Here at White Sands in New Mexico, the dunes retain their bright white while the distant mountains are bathed in blue. PHOTO BY GRACE SCHAUB

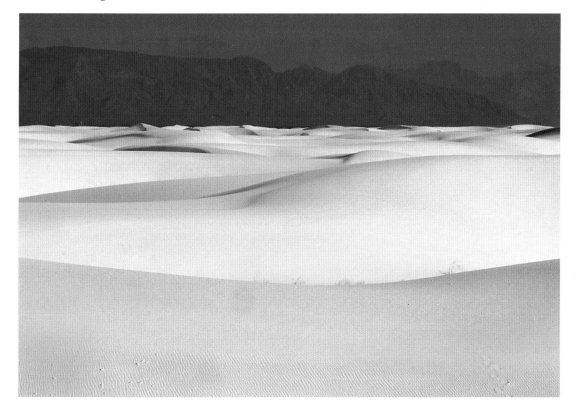

reference. But these filters tend to serve more as lens protectors than as corrective accessories. In some cases, they are options that can be put in place to enhance long-distance landscape photographs.

Fog

If you want to see some amazing fog, head for Maine or the Allegheny Mountains in the spring or the Sacramento River Valley in winter, when the Tule fog rolls around. Fog lends a touch of mystery to every landscape and creates abstractions out of everyday scenes. It also eliminates the sense of distance and makes those subjects that emerge seem as if they sit on a perspectiveless plane or float in midair.

Lighting effects in fog are highly changeable. Fog can be white or deep gray, an effect that can be altered or enhanced with exposure controls. I've also seen bright yellow fog, gray fog in which the deep red disc of the sun seems to float, and milky white fog that acts as the ultimate diffusion filter.

My favorite time to work in fog is when it is in motion, or transition, and the clear sky and the mist begin to mix. This is when small

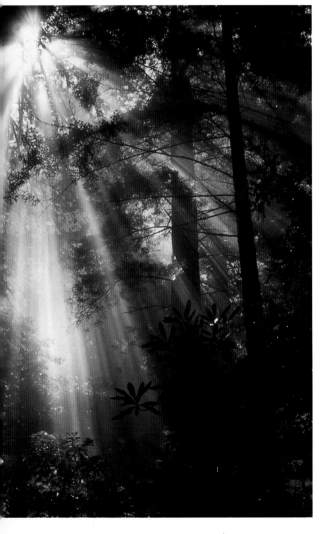

Fog is one of the more intriguing atmospheric phenomena. Its effects change with density and the height of the sun in the sky. It can be slightly underexposed to make it more ominous or, as shown here, slightly overexposed to create a soft diffusion filter over a scene. This scene (top) was photographed in Napa Valley, California.

While an enveloping fog is fascinating, perhaps the most interesting time to photograph fog is when it is clearing and shafts of light are cutting through it toward the ground. This scene (bottom) was photographed in Redwood National Park, also in California. The point source of the sunlight is dispersed by the overhead branches and diffused by the wisps of lifting fog.

fog banks and isolated wisps move through the air. Those isolated "foglets" break up the sun's rays and create a border between the real and ethereal worlds. I've always found the Oregon coast, the rocky shores of Maine, the Everglades in Florida, and Washington's Olympic forest great places to find this effect. The same approach can be used when heavier fog begins to disperse. The tension between the departing diffused and incoming hard light makes for very dramatic photographs.

Overcast Sky

People tend to believe that an overcast sky means poor picture quality. Many photographers, however, prefer diffuse light over bright sunlight. When overcast sky persists, concentrate on subjects that eliminate the sky from the frame. There seems to be no poorer picture than one where a blank, gray sky dominates the upper portion of the frame. On such days, it's best to work with details on the ground and seek pleasure in their texture, design, and color.

My wife and I were once on assignment to photograph a number of locations in the Ardennes region of Belgium and had five days to cover a lot of ground. Unfortunately, it rained nearly every day, and the sky never got above the level of brightness found in the most dismal motor vehicle office. Being eager, we dutifully went through the assignment list and shot castles, farms, and the sad but awesome battlefields. We also photographed cultural details that left the sky out of the picture. Needless to say, most of that assignment ended up in the round file, and much film and effort were wasted. Only the detail shots survived the edit.

That experience taught me to accept fate on such days and only photograph subjects that benefit from the diffuse and at times somber light. A professional doing portraits outdoors will seek open shade rather than work in bright sunlight. We should take a tip from that common wisdom and approach subjects under such light in similar fashion.

Overcast means different things in different parts of the country, however. This book is being written in two locations: in the East, on Long Island, New York, and in the West, in Taos, New Mexico. Overcast in the East usually means socked in, with a heavy shroud of deep gray that shows little or no breaks. In the mountainous West, where the sky always seems bigger and the views can be 180 degrees to the horizon, it varies within the same sky from a light, even gray to deeper, more somber tones, and everywhere in between. Right now I'm sitting on my porch in Taos on an overcast day with low-level illumination. To the north and close to the horizon, the sky is bright white. From there it rises gradually to a deeper gray, which envelops the mountain. To the south, the sky is even darker, interspersed with dark gray veils reaching toward the ground. It's raining down there.

When the sky becomes the "softbox" and is the source of general illumination, the shadows become soft and contrast weakens. Just consider that type of sky as a shade drawn across the sun and work accordingly. There are photographic pleasures to pursue on such days. It's just that including the sky in the frame isn't necessarily one of them.

Snow

Close-up photography has revealed that every snowflake is unique, a fairly mind-boggling idea, given that billions of such flakes make up that clump of snow that's been plowed to the edge of the parking lot. While we usually deal with snow as a mass of white, there are many colors to snow and ice. I've seen blue snow at the edge of glaciers, warm, golden snow in the late afternoon, and even red snow at sunset. Because snow is crystalline, it has texture; because of its highly reflective quality, it serves as both a fill card, reflecting light onto every-

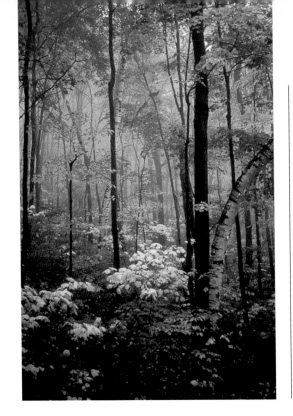

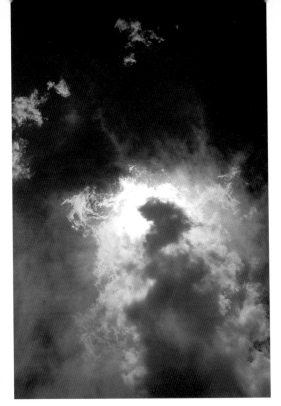

Cloudy weather is not necessarily a signal to put the camera away. Even cloudy days have potential. They can offer a diffuse light source that might be just right for close-ups and even scenics. Though we usually associate photographs of changing autumn foliage with brilliant light and saturated colors, much of that season is not filled with sunny days. This quiet moment (above left) on Mount Greylock in Massachusetts shows good color play even in low light. PHOTO BY GRACE SCHAUB

It's usually a good idea to eliminate the actual sun from the frame. This image (above right) belies the rule and shows that it can be included as long as there is some atmospheric filtering to keep it from causing flare in the lens or overwhelming the other light values in the scene.

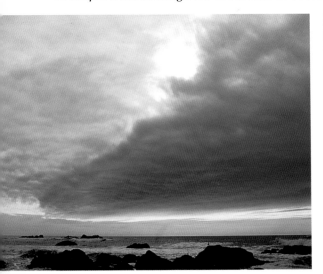

This cloud bank over the Pacific near Half Moon Bay in California was just moving onshore. As it moved, it parted, then closed off the sunlight. This photograph was made when the edge of light at the base of the cloud cover became reinforced by the briefly open window to the sun in the upper portion of the frame.

thing around it, and as a mirror of the colors that are reflected onto it.

That high reflectivity can create high brightness values and scene contrast. If you look at a snow-covered mountain, with the peak surrounded by blue sky and billowing

clouds, you'll notice that the area of snow is usually brighter than any of the clouds. Likewise, in deep woods, the snow dominates the highlight portions of the scale.

Because snow is a mirror of the lighting conditions, a gray sky means gray snow. It's difficult to get a clean shot of snow on overcast days, and using exposure compensation may create a false impression of the other values within the scene. If you don't want to switch to black-and-white photography, which emphasizes texture without the distraction of color, then accept the fact that the lower contrast will yield duller images of snow.

Perhaps the most attractive lighting for snow is crosslighting, when rays streak over the surface in the early morning or late afternoon. This emphasizes texture and spills light onto other parts of the scene. Because the angle of incidence equals the angle of reflection, follow the light that kicks off the snow's surface and you'll probably find some interesting effects.

Clouds and Stormy Weather

Some photographers refuse to photograph under a blue sky. They prefer the turmoil and drama of days when clouds tumble through the sky and when lightning dances along the horizon. Their ideal is a sky with a variety of texture and tone. They spurn blue sky as bland. These storm chasers consider a sky in motion to be a real source of inspiration.

Clouds always have texture. You can see this by watching billowing cumulus clouds as they create amazing patterns and forms in the sky. When exposed properly, all their texture is revealed. Unfortunately, many photographs render them as bright, puffy things that are used solely as pictorial elements to break up a deep, blue sky. When you really look at clouds, however, it's very rare to see just bright white.

Clouds are usually brightest white at the edges, where the vapors are thinnest. The

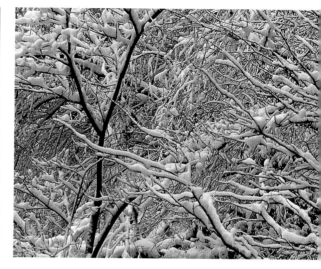

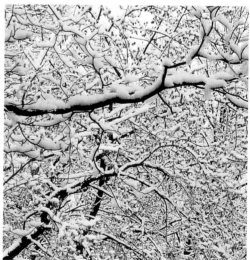

Snow serves as a perfect reflector of the color of the prevailing light. The mood of the sky is echoed in every flake. Here, snow-laden branches are shown at different times of the day. The photograph with the blue cast was taken in early-morning light, just after the snowfall had stopped and the clouds had cleared from the sky. Later, when the sun returned, the bright white snow made for an almost pure black-and-white rendition of the scene, even though it was photographed on color film.

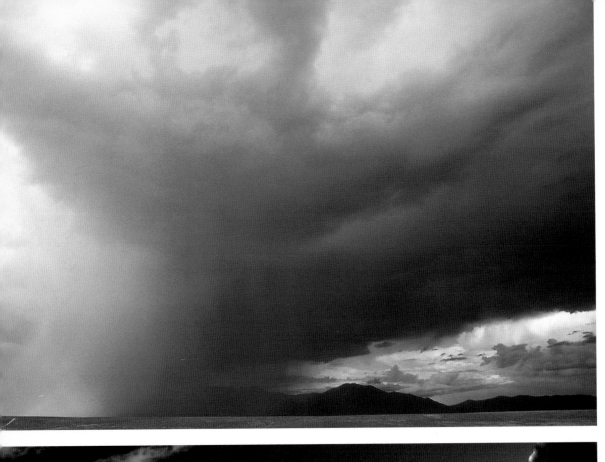
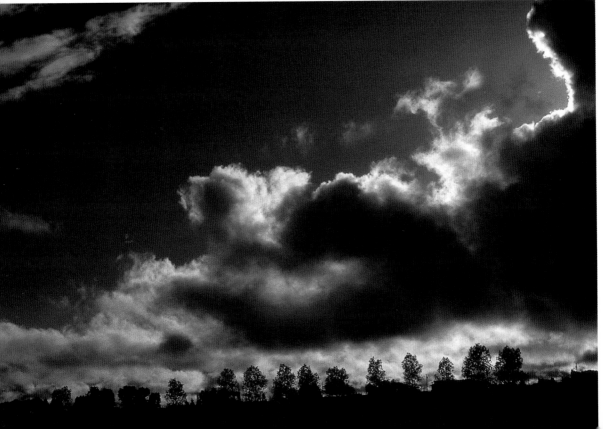

clouds take shape through the grays and deep tones in the center and underneath. Clouds also contain a host of colors and often show blues, silvers, and grays that are reflections from the sky and ground. As their edges are moved and changed by the prevailing wind, they produce new formations in the constantly changing show above us.

We all love cumulus clouds because of their variety of shape and form. Other than getting hung up on mountain peaks, they tend to travel on their own way and mind their own business as they metamorphose from one shape to another throughout the day. Cirrus are higher, thinner clouds that are composed more of ice crystals that sparkle in the late-afternoon light. They seem to be in another world, floating high above us, seemingly unconcerned about the affairs below.

Clouds are fascinating unto themselves, and many days can be spent contemplating and photographing their shapes, colors, and forms. But they are also the light shapers of the earth. They can dominate and change the prime light source through their accumulation or by layering in bands that filter the light in a myriad of ways. They can spread in clusters and create spotlights and shadow play. They can build into massive thunderheads, sending crystals, vapors, and occasional bolts of electricity toward the earth. Or they can serve as reflectors of the setting sun and dazzle us with their variety of colors and shades. Many photographers are inevitably drawn to the study and photography of clouds. They are, in some way, the essence of what color, texture, and tone are all about.

Stormy weather provides many exciting picture opportunities. The light patterns constantly change and shift, and an infinite variety of forms fill the sky. August is monsoon season in New Mexico. In the early afternoon, the clouds begin to build, and at one point the sky gets quite ominous. The best times to photograph are as the storm builds and after it begins to dissipate, when the potential for rainbows is high.

At top, storm clouds are racing out of the western sky. The massive cloud seems to be spreading its wings like an eagle as it swiftly approaches.

Deep, dark clouds race across the sky as rain falls on various parts of the scene at bottom. The slightly brighter sky in the distance makes for a perfect tonal juxtaposition with the darker clouds.

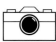

Seeing Color

Just after the sun sets, the light coming from below the horizon reflects off the sky onto the water and back again. It fills the world with a dazzling array of texture, color, and tone. While those moments seem brief in relation to the rest of the day, they are a profound reminder of the passage of time. They signal a respite between the often hurried day and the calm of night. That transition is a time for quiet contemplation and for bathing in the refreshing beauty of color and light.

The effect of color on the eye, and thus the mind, is profound. It influences both mood and attitude. We adopt color associations from our culture and create our own frame of reference through experience and personal affinities. We relate color to virtually every aspect of our lives and use it as an important indicator of time and place, fear and attraction. A deep blue sky, for example, is certainly more reassuring than a green one. Deep within our subconscious, the oranges and reds of deep autumn evoke more than just an understanding that the season is undergoing a change.

Painters have studied the influence of color on emotion and consciously applied it in their work. Compare the deep umber and ochre of Rembrandt, for example, with the vibrant colors of the Fauvists. Feel the effect of Picasso's blue period and that of

Renoir's golden light. Naturalist painters have always known that as colors became lighter, distance was being expressed; that blue marks distance; and that complementary colors of different intensities offset subjects as much as shadow and line. Mod-

If there is one time of day when we are most conscious of color, it's when the sun sets. If sunsets were always the same, we'd hardly notice, but their variety is part of their delight. Here in the Florida Everglades (top), the sky and water become one. The orange, red, and yellow near the horizon give way to purple higher in the sky.

Why is the sky blue? According to scientists, air molecules are very small, and when sunlight scatters through such small particles, it tends to create color toward the violet end of the spectrum. The sky is largely composed of violet, with a good dose of blue and a bit of green, yellow, and red. The result is the familiar sky blue. The colors of the clouds result from the light scattering through larger particles, reflections from the earth, and the influence of the prevailing color in the sky. And the colors of the earth, rocks, and plants result from varying degrees of absorption, transmission, and reflection of the prime light, a dance that gives us every shade and nuance of the visible spectrum.

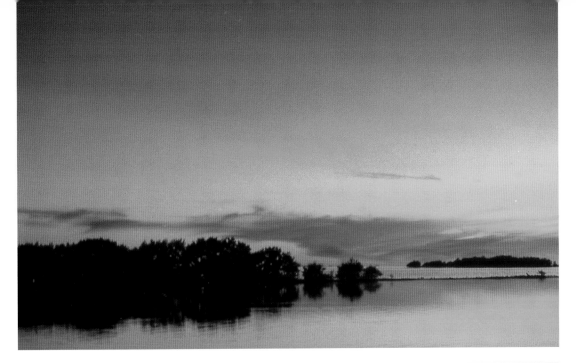

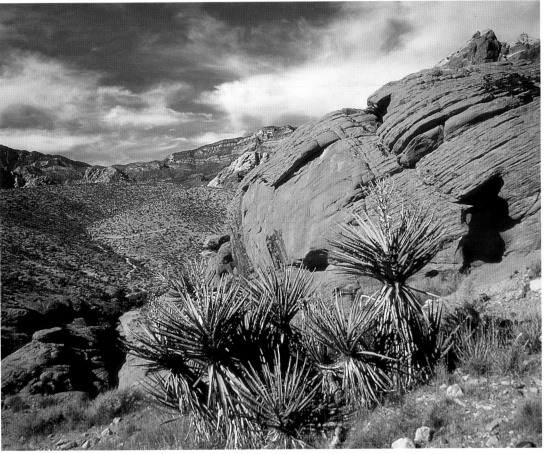

ern painters have used pure color as vibrational fields in nonrepresentational works that affect the viewer on both a visceral and an emotional level.

The colors of subjects are highly influenced by the color of the prevailing light. On a sunny day, we see what we consider the normal, or associative, color of a thing. An apple is red, and a banana is yellow. But when the color of the prevailing light changes, such as at sunset, that "normal" color undergoes a change. The result is a mixture of the base color of the subject and the often overwhelming color cast of the light. In some cases, the eye sees color differently than the film records. During the bright light of day, these formations in Joshua Tree National Park in California are light brown to brownish white. At sunset, their color deepens, and they reflect a near amber glow.

While it could be argued that painters have more control over their colors than do photographers, this does not mean that a careful consideration of color by photographers would be a waste of time. Indeed, any photographer using color film will do well to understand some of the basic tenets of color effects and to seek to apply them in his or her work.

Let's begin by defining some terms. Color is described by three basic characteristics: hue, saturation, and brightness. Hue is how we identify a color, such as yellow, blue, or green. Saturation is the vividness or purity of the color. Pastels have low saturation, like an old wall faded by the sun, while a freshly painted wall is highly saturated. Color brightness can be thought of photographically as its metered value, or light intensity. These values can be plotted by instruments to place a certain color within a relative color space. What's more relevant for the photographer is a more subjective way of dealing with color, one that takes into account how colors interact with each other and how they can affect an emotional or visceral response in a photographed scene.

Color Vision

In and of itself, light has no inherent color. Thanks to Isaac Newton, we know that when we pass light through a prism, that colorless, white light is composed of bands of color, actually frequencies on the electromagnetic spectrum that we can see. The visible spectrum is sandwiched between ultraviolet and infrared. Stretched far enough, the electromagnetic spectrum includes things like gamma and radio waves. We can't see all those waves, however, and we see color in a fairly narrow band of all those wavelengths.

The eye contains receptors that work in concert with certain frequencies, and we see those frequencies as certain colors. What we call red is actually a wavelength of

about 700 nanometers; the blue light of the sky has a lower frequency caused by the scatter of shorter wavelengths by the air itself. If that scatter were a few degrees different, we might see a red sky constantly above our heads.

Describing color as a neurological reaction to wavelengths is in no way meant to denigrate its wonder or reduce it to a mere scientific phenomenon. Let the idea sit for a while, and start looking around. You may begin to appreciate the amazing energy that constantly surrounds you. This can open you up to some very powerful ideas about how color can be used in visual expression.

A subject's color results from its selective absorption and reflection of various wavelengths. The degree of absorption affects whether we see something as light or dark; likewise, things absorb some frequencies of light more than others, then reflect or transmit light as its color. If something looks white, such as brightly lit snow, the wavelengths of all the separate colors have interfered with one another and in effect canceled any color out. If something looks black, it absorbs all the frequencies and reflects none of them.

The quality of a color is influenced by the subject's selective absorption and reflection of light, the brightness level of the light source, the surface of the subject, and the color cast of the prevailing light. There is always a dance among the quartet.

If you look at a tree with very dark bark in the shade, it will look almost black. Look at the same tree with a shaft of light striking it, and that black may appear yellow. We more or less take this for granted and say that the tree is lighter because it's being struck by direct light. Part of that change, however, results from the effect of the tree's surface and how it alters the absorption and reflection of the light. Thus, the textural surface can affect how we see the subject's brightness and color.

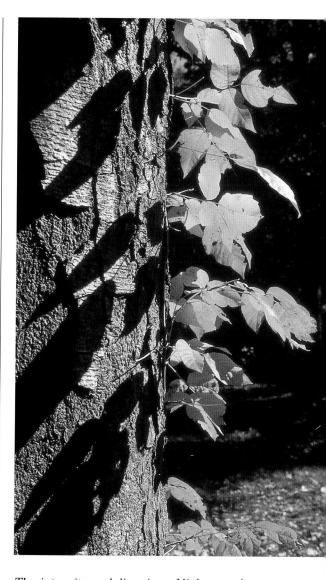

The intensity and direction of light can alter color perception, depending on the base color and surface texture of a subject. The bark of this tree is normally dark gray-brown. When struck by a strong sidelight, however, the dark surface picks up yellow, and you can see every rill in its surface. Of course, much of this change depends on your point of view. If you look at the tree from the other side, away from the light, it would once again take on its "normal" appearance.

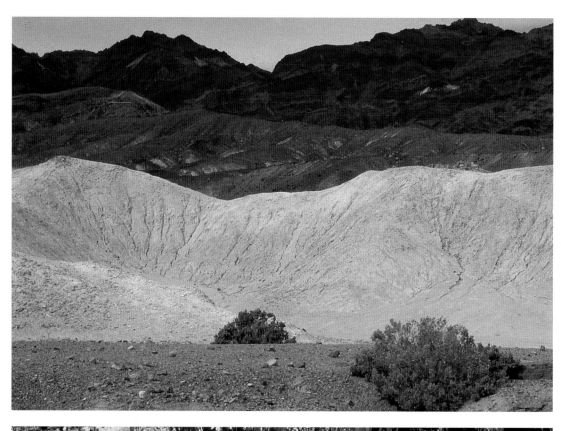

The overall quality of the light source can have a profound effect on color perception. Light and dark tints of color that in flat light would show as one hue become more differentiated in bright light—the effect of color contrast. Yet if that light is too bright and the surface is glossy, we will get greater interference, and thus some of the color that we might see in flat light becomes washed out, or replaced by white. If the surface is matte, the reflection becomes more diffuse, and we see more color. Thus, the greater the surface reflection, the less the color richness or saturation we perceive. Rough surfaces throw off all sorts of reflections that can vary the color in many ways.

Atmospheric effects also alter color, as does aerial perspective. If you look at a range of mountains from a distance, for example, they appear blue. When you walk or drive closer to them, however, you see them as green, red, or whatever color they might be. The same goes for the color changes subjects seem to undergo throughout the day. The inherent color of sandstone formations does not change, but photographing those formations late on a clear day will yield the most spectacular results. Those afternoon colors are influenced by the prevailing light. Their amber tint results from the color bias of the light as it travels longer distances later in the day.

The color of any one thing is influenced by the color of subjects around it and how those subjects absorb and reflect light. It's as if we exist in a world of color mirrors and reflectors that bounce light from one subject to another. This sets up the world of color relationships and creates many of the color-enhancing vibrations and associations we see around us.

In short, the way we see color is almost subjective, and it is certainly conditional. Just as brightness is influenced by a host of factors, color itself is always changing and being affected by the energy around it.

Color Relationships

While the color of any subject and scene changes throughout the day, photography is about capturing a special moment in the continuum of time. The color relationships within a scene can create feelings of harmony or discord, of calm or excitement. Certain color relationships form the basis of color play that has proven fruitful for artists through the centuries.

There are special sets of colors that seem to form unique bonds. One such set is complementary colors, such as red and green, orange and blue, and yellow and violet. If you stare at one of the colors for a minute and then look at a white sheet of paper, its complement will form before your eyes. This is known as an afterimage. When both colors are present in the same scene, they will always intensify one another. For example, a red flower will always stand out more against a field of green than against a blue sky.

The saturation and brightness of these complements also affect color perception. If the two complements are of equal intensity they tend to vibrate, as the eye seeks the most intense color first. The fight for visual dominance causes the colors to shimmer. In

The character of light affects how we perceive color. In California's Death Valley (top), a bright, overcast day provides diffuse illumination that reveals every nuance of color in this scene. Conversely, hard, contrasty light combined with a slick surface creates white "interference" that cancels out the slate blue color of the face of this rock (bottom) in New York's Catskill Mountains. Only the rough surface of the rock allows us to see some of the color in its "internal shadow." Likewise, the brightness makes the red pop so that we record masses of color rather than any subtle differentiation in the leaves.

BOTTOM PHOTO BY GRACE SCHAUB

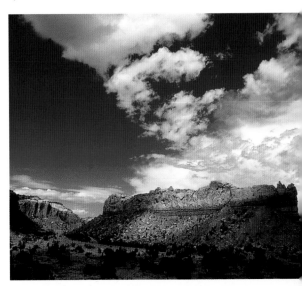

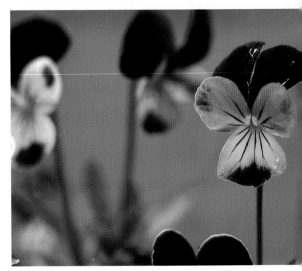

Certain color relationships seem to impart more visual energy than others. When you want a subject to pop, place it near or against a background of its complementary color. This brilliant red flower (above left) sits against a split frame of color—brown on the top and green on the bottom. Cover the top and then the bottom with your hand, and compare how the red vibrates against the two backgrounds. The green-red combination produces the most visual energy.

Photographing details in red-rock country (top right) is exciting, as it allows you to create images with intricate patterns and designs. When the sky is deep blue, however, you might want to step back to get the big picture. The complements of orange and blue create strong images.

Yellow and magenta are complements, colors that the flower at bottom right incorporates in each of its petals. The addition of rich green in the background enhances the vibration and begins to approach color clash, or visual shock. PHOTOS AT RIGHT BY GRACE SCHAUB

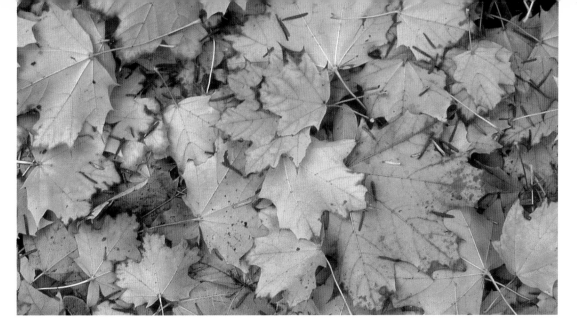

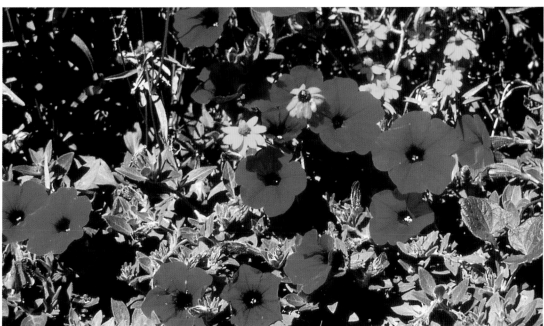

Color saturation is the degree of color intensity. It can range from low to high and is dependent on the color of the subject and, perhaps more important, the brilliance of the light striking it. The top photograph was made in low light under a canopy of trees, and thus the color saturation is quite low. If photographed in bright light, these yellow leaves would still show their variety but would be much more highly saturated.

The color saturation of the field of flowers at bottom is very high, intense to the point of excess. The saturation is boosted in part by the type of film selected, but it's most influenced by the way the brilliant light causes the purple flowers to fluoresce. These factors combine to make the color of the flowers as hot as it can be.

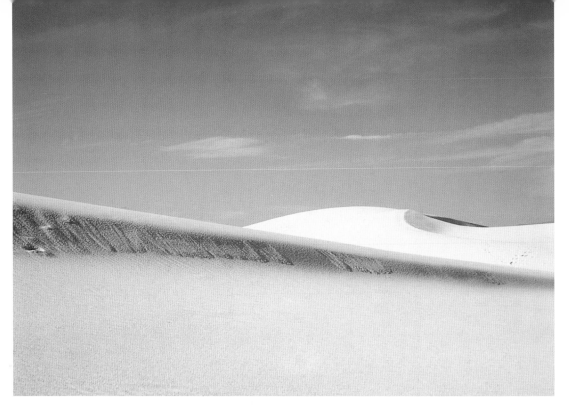

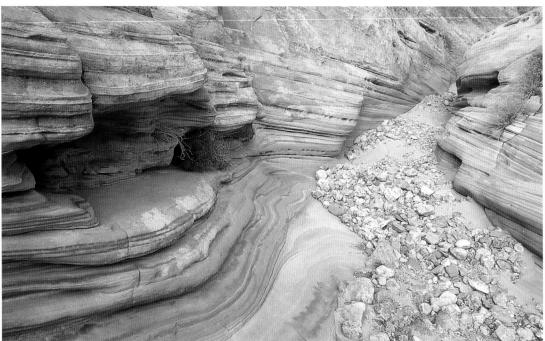

The mood of the prevailing light and subject are important matters that help communicate a sense of place. Compare the visual effect of the dunes (top), a decidedly cool scene dominated by blue and neutral tones, with the desert wash (bottom), a much warmer locale and rendition.

a photograph, this may flatten the scene, although it's rare to get two complements of exactly the same intensity. Thus, the red flower will be more vivid against a darker or paler field of green.

The complementary effect may also explain why we are so dazzled by sunsets. When the orange-red color intermixes with blue, we tend to pause to consider the display. Mixed colors in the sky are always more fascinating than a continuous-tone blue.

When colors come from the same general band of the spectrum, they are said to be of the same family. They harmonize with one another and have a great effect on mood. We tend to describe these families as warm (red, yellow, orange) or cool (blue, violet, green). Most people tend to agree that cooler color schemes are more restful, while the warmer or hotter color plays are more intense and more visually stimulating. A cool image may be made of a forest floor under a canopy of shading trees. A warm color scheme might be a range of colors in a desert sandstone formation.

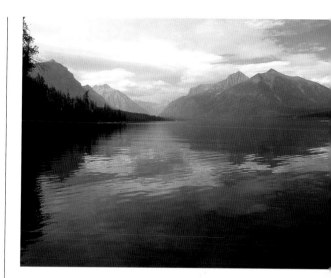

When a scene encompasses a color family, the visual effect can be quite harmonious, but you need to avoid visual monotony. Look for color kickers—other colors to offset the dominant ones—or work with color contrast, including different brightness values of similarly colored subjects.

In this scene from Montana's Glacier National Park (top), the slightly overcast sky and aerial perspective effect create a calming scene that, though pretty, lacks visual interest. There's no contrast or color change to attract the eye.

This plant grouping (bottom) is all green, but visual variety is added by the use of color contrast. While the background in and of itself might be interesting, the contrast between foreground and background adds dimension to the scene. PHOTO BY GRACE SCHAUB

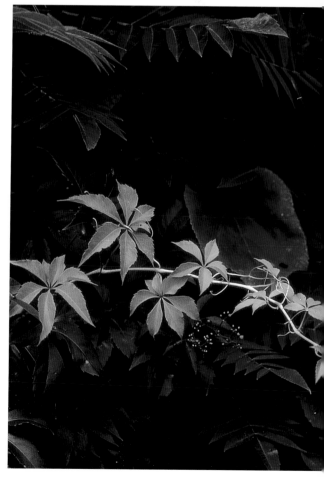

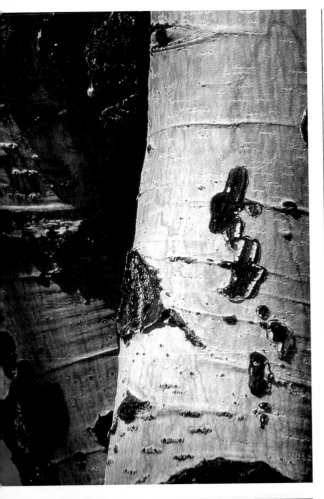

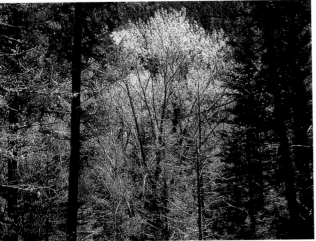

This is not to suggest that such images cannot benefit from a hint of complementary color thrown in. Complements accent each other, and a dash of cool colors in an overall warm color scheme can be very effective. Playing with color families and spicing them up with complements is what some people might consider candy for the eye.

Another fascinating color effect is provided by monochromatic color schemes. When we seek monochromatic compositions, we are exploring a relatively narrow band of color with slight variations in saturation and brightness; hue, however, remains in a tight range. This is different from black-and-white photography, where we are dealing with shades of gray. It is close to the black-and-white experience in that texture and tonality are explored, in this case via color contrast. When working in monochrome, exposure variations often enhance any differences in brightness and saturation effects. A technique known as bracketing, using a range of exposures in addition to the one recommended by the meter, is an easy

Monochrome describes scenes that are dominated by one color. By showing only the aspen trunks in this scene (top), and not the brilliant leaves or surrounding countryside, a monochromatic rendition is created. The bark has a touch of color, some red and magenta, making this different from a straight black-and-white film version.

Using black-and-white film is working in the ultimate monochrome realm. Black-and-white film can yield images (bottom) that deal with texture, design, and tone without what some consider the "distraction" of color. In truth, many black-and-white prints have a color of their own. This can result from the color tint of the paper or from the use of chemical toners that can impart anywhere from a cold blue to a warm brown overall color to the image.

Color field painters of the mid-twentieth century worked with color as an emotional space. They used the vibration of color families, color complements, and color relationships to evoke a particular mood or contemplation. While many people look on these canvases with some skepticism, photographers would do well to study them, and color theory in general, to gain inspiration and understanding. Photographing color for its own sake is also a good practice every once in a while, as it removes the need to always place a context or narrative within the scene. These photographs are from two rolls of film exposed while hiking along the cliffs at Torrey Pines State Reserve in California. Each deals with the arrangement, flow, and intensity of color and the way it moves the eye through the frame.

way to get contrast, color, and brightness variations. A taste of complementary color can also be used to add visual spice to a monochromatic scene.

The color schemes you choose for your photographs come down to your taste and subjective reaction to various scenes. There are no rights and wrongs in what you choose. Studying color effects will open your eyes to more possibilities and allow you to make more informed choices. Taking chances with color can also lead to

some exciting results. With that in mind, here are some brief color exercises you might like to try:

• Look for complementary colors to off-set dominant colors, those that take up most of the scene.

• When the color cast is strong, look for offset and accent colors, such as warmer colors with an overcast sky or cooler colors late in the afternoon.

• When working in color families, look for complementary colors as accents.

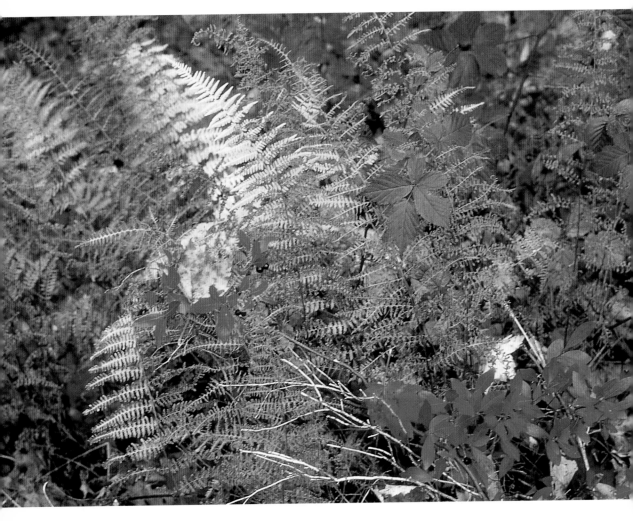

Autumn is a great time for color studies. The variety of colors—their hue, intensity, and satura-tion—is infinite. In truth, color everywhere is always changing, even if we fail to see it. The great thing about autumn is that we can't avoid seeing it. Each section of this field shows some facet of color play, from color relationships to variations within a color family.

- Create a color shimmer with equally valued complementary colors.
- Use exposure techniques to change color intensity, overexposing for paler colors, underexposing slightly for increased saturation. When shooting monochromes, vary exposure plus and minus to explore color contrast effects.

- In a landscape, cool colors imply distance. Create scale and perspective with complementary colors in the foreground.
- If a foreground subject has a dark color and the background is dark, seek complementary colors to increase contrast. The same holds true for a light foreground and background.

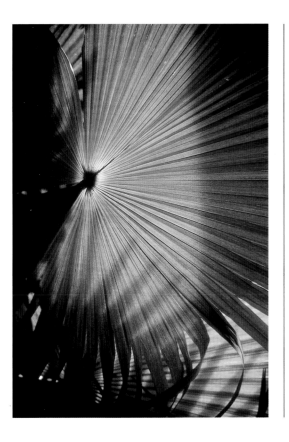

- A bright color will always dominate a more muted color. Use of complementary relationships will increase the visual play.
- Explore monochrome effects in different hues. Monochrome does not just mean black-and-white subjects photographed on color film.
- In a scene with a family of colors, compose so that one hue dominates the frame. Allow the other hues to play supporting roles.

Within a hue are infinite variations, determined by the prevailing light, its brightness and direction and the way the subject transmits and absorbs the light. Though this palm frond is green, the shades of green and their saturation vary considerably throughout. Indeed, the frond also displays a good deal of blue and yellow. The form and pattern of the frond are perceived by the variety of color and brightness throughout. PHOTO BY GRACE SCHAUB

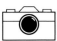
The Eye and Film

The eye and film see differently. The eye roams around and focuses on many points within its field of view. Film sees in square or rectangular frames, and focus is fixed on one plane, modified by the depth of field created by focal length, aperture, and camera-to-subject distance. The eye adapts and constantly balances color, regardless of the source of illumination. Film records color influenced by the prevailing light. The eye dilates and constricts to adjust for changes in brightness. At the moment of exposure, the aperture and shutter speed settings cause the film to receive the energy of the light in one fixed pulse. The eye and the mind respond to light, causing a whole chain of associations and subsequent actions depending upon its intensity and content. Film reacts to light and is changed by its intensity. In short, the eye and mind are both receptors and active participants in perception, whereas film reacts to and records light according to set rules of exposure and film sensitivity.

The above may seem obvious, but one of the dangers with automated cameras is that we presume the film will respond to what we see in the viewfinder regardless of the circumstances or lighting conditions. Understanding how the two differ in their response to light and how we can modify film or camera function to make them more in tune with what the mind perceives and interprets is one of the most important, and perhaps least understood and appreciated, aspects of photography.

The eye is an amazing instrument that continually sends messages to the brain. These electrochemical signals are woven with other impulses to form images, the codes that form our perception of the world. By comparison, the camera is a machine that captures and holds different brightness values on film. We can only ascribe value and connotation to those brightness values recorded on film later when we view the image as a representation of something we previously saw. The eye is active; the camera and film are passive.

How Film Records
To get a better sense of the difference between what we see and how film records, let's briefly examine the mechanics of film and exposure and how this differs from human vision, as well as how various techniques may be employed to emulate on film what the mind sees. Closing this gap usually leads to better photographs, or at least to a closer record of what inspired the snapping of the shutter in the first place.

Film is composed of light-sensitive grains, known as silver halides, suspended in an emulsion that is coated onto a clear plastic base. The grains, or crystals, can be ran-

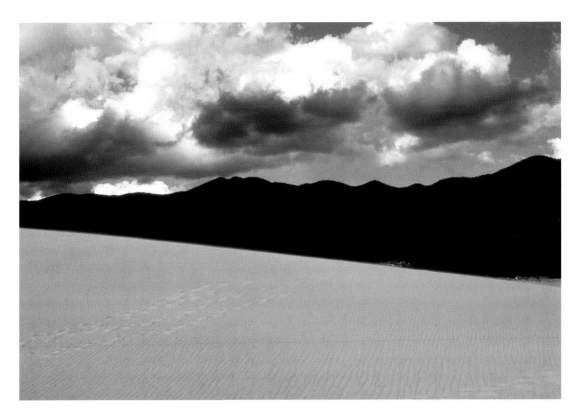

This scene does not appear as it would to the human eye. The eye scans around a scene and reacts to changes in light levels. If you were standing in this spot, you'd see more detail in the mountains, brighter sand, and an entirely different mood in the sky. Film reacts to light in one fixed pulse determined by the set exposure value (aperture and shutter speed). For this image, a meter reading was made off the bright sand. This caused the mountains to go black, losing detail, and the sky to deepen.

dom or more uniform in shape, depending on how the film is built. The important thing about grain is their efficiency of light capture. This determines the film's light sensitivity, known as speed and expressed as an ISO number. Generally, the faster the film, the larger the area or size of the light-gathering crystals. In a given type of film, faster films will always have crystals with greater area than slower films.

The practical result is the grain of the final image, the salt-and-pepper pattern of crystals that may be manifest when enlarge-

ments are made. Excessive grain is less of a concern today than in the past, when some films exhibited grain that actually interfered with the visual experience of the picture. Today photographers sometimes seek out film with large grain structure or enlarge images to very big sizes to emphasize grain for creative ends, generally to emulate impressionist or pointillist paintings or to add a nostalgic, ethereal feel to an image.

Photography works because light is a form of energy that can influence and change matter. In photosynthesis, the energy of light

Two eye-film differences are illustrated here: accommodation of brightness levels and perception of sharpness from near to far. The formation on the left has lost detail because of high scene contrast and the inability of slide film to bridge the gap. An exposure reading revealed a three-stop difference between the light and dark areas. Even though I could see as much detail in the formation on the right as in the one on the left, slide film could not accommodate both values. I used the exposure reading based on the brighter surface. This caused the rock on the left to be rendered darker than it appeared in nature. If, on the other hand, I had exposed for the dark area, the brighter rock may have been too bright and lacking in detail in the image.

Another part of exposure consideration is the use of aperture to control depth of field. The picture sharpness from foreground to the farthest mountain resulted from setting a narrow aperture for maximum depth of field. The eye does not see in this way. When we look from near to far, our eyes constantly adapt and focus on different distances. We then process this information to include scale and distance. The illusion of sharpness may be the same, but the way we achieve this on film and with our eyes is quite different.

serves as a catalyst to complex reactions by which a plant creates its nourishment. In photography, light acts upon the grains and causes them to change. This process of change creates what's called a latent image, an invisible film record. When the film is subjected to a series of chemical baths, the image becomes amplified and thus visible to the eye.

All exposed film begins as a negative, a reversed record of the intensity of light values in the scene. The intensity of light in the scene is proportional to the density, or degree, of silver buildup on the film. More density, and thus a darker film record, indicates where a greater intensity of light has struck the film. Less density indicates where less light has struck the film. These light intensities in the negative are reversed when a print is made. When you look at a negative, a bright area in the scene looks dark and a darker area in the scene looks light.

Think of a negative of a photograph of a bright lake surrounded by dark woods. Inspection of the negative would reveal a dark lake surrounded by a light area that defines the trees. There may be rocks and bushes on the shoreline revealed by light reflecting off the lake. These areas would show up in the negative as various shades of gray, in black-and-white negatives, or as a buildup of density and color intensity, in color negatives. All the brightness areas would be in direct inverse proportion to their brightness in the scene. Thus, degrees of light intensity in a scene show up as degrees of density on the film. This range of densities is the tonal scale of the photographic record.

This system, in which brightness values in the scene are represented by tonal values on the film, is at the heart of the photographic process. In negative films, the tonal values are reversed when a print is made. In slide films, the reversal is accomplished by chemical or physical means during film process-

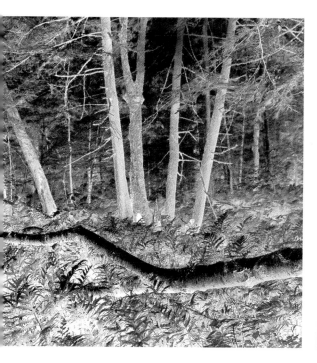
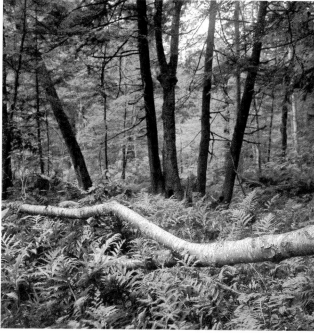

Photography works because the silver-halide grains in film react when exposed to light. When we make an exposure, we form a latent image on film that is amplified when the film is developed in chemical baths. The image formed is a negative—a reversal of the proportional light values in the scene—that is made positive when a print is made. (Slide film is reversed in processing, making, in essence, a positive record on film.) The density of the film record is in direct inverse proportion to the brightness values of the scene. Thus, what is light in the scene is dark on the negative, and vice versa. When prints are made, these values can, to an extent, be adjusted and changed using conventional or digital darkroom techniques. Here, some of the brighter ferns surrounding the fallen tree have been selectively burned in (made darker) to enhance the print.

ing. In both cases, negative becomes positive when the processing cycle is complete.

As you begin to learn about light metering and the ability of film to capture a certain range of scene brightness values, the concept of tonal scale will start to make more sense. The system has been refined through the years to the point that we can predict with some accuracy just what we will be capturing on film when we snap the shutter, regardless of the scene, subject, or lighting conditions. This ability and understanding is at the heart of developing a photographic eye.

Scene Contrast

When you make an exposure, the brightness of light is harnessed to create a visual impression within the fairly strict parameters of the recording range of the film. In essence, light can be dim, bright, or diffuse—it makes no difference to the camera's eye. This does not mean that the mood created by that light—its context and

emotional value—has no influence on the recorded image. Quite the opposite; it often has everything to do with the creation of an effective photograph. But to the camera—and to an extent to the clinical eye of the photographer—the crucial matter in brightness values is the degree of difference between the brightest and darkest areas in the scene. That contrast and the way in which it is handled determine how the scene will be rendered on film.

The difference between light and dark areas is referred to as scene contrast. This relationship can be measured through the use of a light meter. Used correctly, the meter will read out the differences and allow you to make informed decisions about how the light and subjects will be rendered. Therein lies the difference between the human and the photographic eye. The photographic eye makes judgments about brightness values in the context of creating a film record. The human eye considers light for its own sake and instinctively reacts to changes in brightness values as it scans the scene.

Color Balance

The color of light affects photographs in two linked ways. One is the color of the light source itself; the other is the way that light source affects the subjects and objects on which it falls.

Light is essentially colorless as it races toward us from the sun. As it passes through the atmosphere, it is subject to scatter and reflection and reaches us with a color cast, such as the bluish light in distant mountain valleys or the amber glow of late afternoons. If that cast is strong, we notice the shift from "normal" daylight with our eyes. In general, we adapt to the change and balance the light in our minds.

Film cannot do this. It is made to record true color only within a certain range of color casts, known as color temperatures.

These color temperatures have nothing to do with the temperature we read on a thermometer. They are determined by scientific methods and a system of light classification based on the burning of a solid body and the resultant color of light it radiates. As that solid body is heated in the lab, it begins to radiate color—first red, then orange, and as the temperature rises, on to blue. Thus, red and yellow light have a lower color temperature and blue a higher one. Most color film is manufactured to deliver true color rendition at about 5400 degrees Kelvin, close to the color temperature of light at noon on a sunny day. Overcast sky and certain atmospheric effects that create a blue cast are higher in color temperature, about 8000 degrees K. An amber sunset tends to be lower in color temperature, about 3200 degrees K.

The fact that film cannot adjust to changes in color cast explains why some photographs don't match the "memory colors" we may have of a scene. For photographers who want colors rendered as close as possible to those seen by the eye or for those who do commercial photography, an understanding of color temperature effects is critical, as is the use of certain filters to balance the color when required. For me, the emotional content of a scene is more important than balancing color, although I do become concerned with color balance when doing product or portrait photography. However, film selection is usually more important than filters in color natural light photography.

Understanding that in certain instances film sees color differently than the eye is often key to capturing the beauty of what you see on film. You can exploit these supposed limits to your advantage. Think of a foggy-morning river valley without a bluish cast or a late-afternoon sunset without a golden glow, and you'll understand why you don't always want to neutralize color. Indeed, you may even want to accentuate

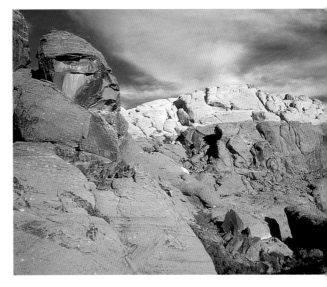

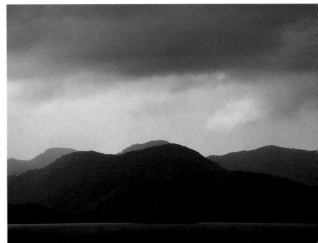

The color of the prevailing light influences how film sees. The eye generally adapts to color shifts in ambient light, whereas film is balanced to record color at a set color temperature. When the ambient light deviates from that color temperature, such as on an overcast day or when the sun sets, that offset may be more apparent than what the eye sees. This desert scene (top right) was made at midday, and the color on film is very much what the eye saw.

At sunset, however, the vines and leaves in the photo above left were recorded quite a bit more yellow—warmer—than seen by the eye.

This distant island (bottom right) at dawn came out much bluer—cooler—than the eye perceived it. PHOTO BY GRACE SCHAUB

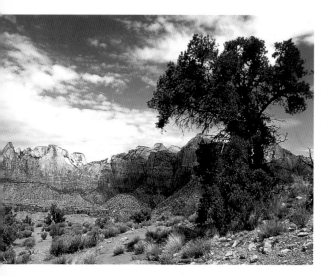

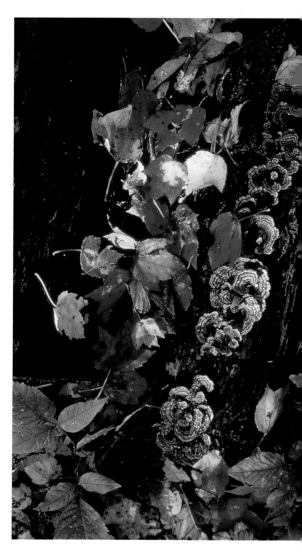

Because color on film is formed with dyes, color rendition is often different than the colors the eye sees. Film manufacturers play with dye sets in many ways. Most of the films sold today have greater color saturation than in the past. This scene in Zion National Park (top left) was made in 1976 on Kodachrome film. At the time, it was considered a slightly warm and deep color saturation film. In retrospect, and when compared with today's slide films, it seems rather tame.

This close-up (bottom left) was made in 1992 on Fuji Velvia film, the first of the supersaturated slide films. The red rock has been zapped with enriched color.

This fall scene (above right) was made on an earlier Fuji film and shows how supersaturation can be overdone. The colors are so saturated that they almost wipe out detail. Color negative films tend to be a bit more moderate in color saturation than most slide films. This may be because they are balanced with skin tone in mind.

these effects through the use of filters and exposure tricks, although nature usually provides enough variety that these techniques may be unnecessary. Waiting for the right light may be more rewarding.

Film's Influence on Color

Many films add something to the color record. This characteristic is referred to as the film's saturation. Films are generally divided into three categories: neutral, saturated, and highly saturated. Neutral films are supposed to record the color as seen by the human eye. Everyone sees color somewhat differently, however, and film dyes, at best, form an approximation of what we see. Neutral film is used mainly for portraits, where an exaggerated skin tone is undesirable, and by commercial photographers who need a true color record for a fashion spread.

Saturated films, like the majority sold today, boost color and generally add more intensity to the colors in the scene. The decision to make films respond in this fashion is a marketing one—film companies have found that people prefer films that deliver vivid color. What's been amped up is a combination of the film's color contrast (and at times its neutral, or overall, contrast) and the very nature of the color-forming dyes. In some cases, these films tend to create more contrast in the scene overall, due to the higher inherent neutral contrast. This becomes bothersome when you're photographing in high-contrast conditions.

High-saturation, or vivid-color, films render colors even more boldly. These can be almost surreal in their color rendition. Certain high-frequency colors, such as brightly lit red, yellow and orange, can look as if they've just received a bright coat of paint. Some of these films boost certain colors more than others—one brand of film might enrich green, while another boosts blue. These characteristics tend to differ from brand to brand and even from film to film within one brand.

Though I could identify certain films that show these differing characteristics, film manufacturers change film emulsions and brand names so often that what was written now would probably be out of date in six months. Critical evaluations for certain brands are often found in photography magazines, although the limits of reproduction may not reveal their true character. The only way to really judge film is to test it and compare it with others yourself.

To test a film's color response, pick a colorful subject, such as fall foliage or a field of flowers, and shoot a roll or two of each type of film you're considering. The simple blue sky, green lawn, red umbrella test is a time-honored way to make comparisons. Once exposed and developed, place the slides or prints side by side and see how they compare. With slide film, using a light box for comparison is better than projection, unless you have matched projectors throwing slides on the wall side by side. The eye adapts to sequential color quickly and you'll be less aware of the differences, so it's best to view slides side by side.

Given that you have a choice of films that offer different color saturation levels, how do you put that information to use in the field? The simplest response would be to use a high-saturation film when you want to boost color, such as with fall foliage, and a lower-saturation film when you want a more muted or more naturalistic record, as when photographing a rural landscape. But you could also exploit the higher contrast of the more saturated film on overcast days, to increase contrast in flat lighting, or the lower contrast of a more neutral film on days with high-contrast lighting.

Raising Contrast

There's one more trick to film contrast. There's an adage in film handling that you

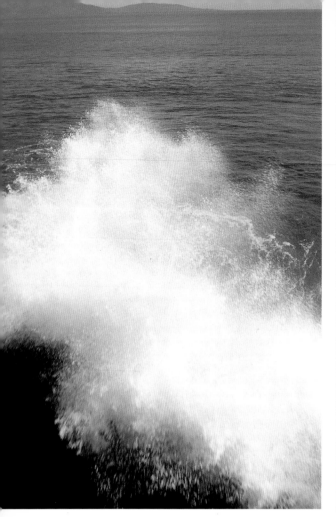
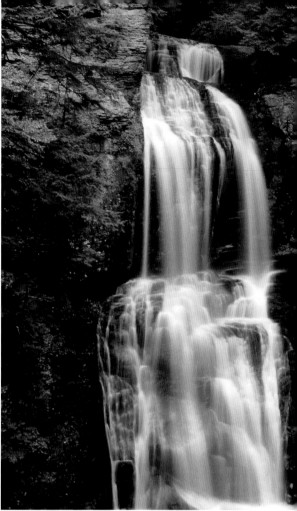

The eye and the camera also deal differently with motion through time. We perceive motion as a continuum through time that unfolds in a series of connected causes and effects. The camera, however, sees time according to how the shutter speed slices off sections of the continuum. At left, a wave is caught at its height by exposing at 1/1000 second. Slow shutter speeds can also be used to express motion. This waterfall in Pennsylvania (above right) is transformed to a continuous flow of light through the use of a 1/8-second exposure.

control density (the rendition of tonal values on film) through exposure, and contrast (the relationship of those tonal values once recorded) through development. To boost the contrast of any film, you or your lab can add developing time to that roll. This is called push processing. If you use this procedure, however, make sure you set your camera's film speed higher than that printed on the box. For example, let's say

you want to increase contrast with an ISO 100 slide film. Shoot this film with your camera or meter set to ISO 200. Then have the lab push the film one stop. Or if you're shooting black-and-white film, shoot at the rated speed and have the lab extend developing time by about 20 percent. This is a good technique when shooting on low-contrast days and when you want to add punch or extra contrast to the negative.

Color negative film does not respond well to push techniques to gain contrast; it's better to overexpose when shooting the film.

Color Cast

There's one more wrinkle on color rendition: Some films are warmer or cooler than others. Here these terms relate to an impression of color rather than to color temperature. In other words, there's an overall bias, or color cast, built into the film. This can be subtle and is less pronounced than in the past, but it still exists. This is more important with color slide film than with print film. Color negative film can be made to exhibit virtually any color cast when prints are made. Any undesired shift that you notice in your first set of prints can be corrected by the photo lab. Slide film is another matter, as the image is a master of the original exposure. Photo labs can make corrected dupe slides, but this may cause other problems. Today, computer imaging can provide more easily obtained corrections.

Your tests will reveal whether a film is warm (slightly yellow-amber) or cool (slightly blue). You can use a cool film to enhance a cool scene, such as a foggy valley, or to balance a warm scene. Conversely, you can use a warm film to enhance an already warm scene, such as adding an extra touch of yellow to fall foliage, or to balance a cool scene, such as snow, which usually records with a blue cast or at least with blue shadows.

All this points out the rich palette offered by different types of film. As you gain experience, you can begin to choose films like a painter mixes paint. Identify two or three films that deliver certain characteristics, test them to understand how they behave, and use them to match the lighting, scene, and your expressive requirements for the scene at hand.

Because of the way film is constructed, you should use the slowest speed film you can, depending on the lighting conditions and the equipment you're using. Slow-speed films deliver the finest grain, richest color, and best sharpness. You're not constrained in film-speed selection when working with a tripod, as you can shoot even the slowest film in the dimmest of lighting conditions. If you're shooting hand-held and working with a telephoto lens, you may have to use faster films.

Black-and-White Film

Using black-and-white film places greater demands on your understanding of how the eye and film see differently. It is an abstraction that is not unfamiliar to us. We all grew up with black-and-white pictures in newspapers and magazines and the legacy of landscape photographs made by masters such as Ansel Adams. Indeed, some would argue that black and white is even more expressive than color, as it allows greater interpretation and manipulation.

Black-and-white film translates color into tones that range from deep black to bright white, with all the shades of gray in between. Though it might not be obvious at first, subject color does have an effect on black-and-white rendition. This can be seen by photographing red and green subjects of fairly equal brightness values in the same scene. If photographed without a color contrast filter over the lens, the red and green subjects are not easily differentiated. If a red filter is placed over the lens, the red subject will record considerably lighter and the green subject significantly darker. The converse holds true if you place a green filter over the lens.

In black-and-white photography, brightness values in the scene translate to a set of gray tonal values on the film. As it is a negative film, brighter scene values record as darker tonal values—that is, they have greater density. Knowing what the film will record in black and white is not as instinc-

tive as it may be with color film; it takes time and practice. Try to see the brightness values in a scene on a scale, and order that scale from deep black to bright white. Look at texture rather than color, and begin to differentiate those values that will record with subtle differences on film. One way to train your eye to see in a monochrome fashion is to study the work of black-and-white photographers, such as Ansel Adams, Paul Strand, Edward Weston, Fredrick Sommers, and Paul Caponigro.

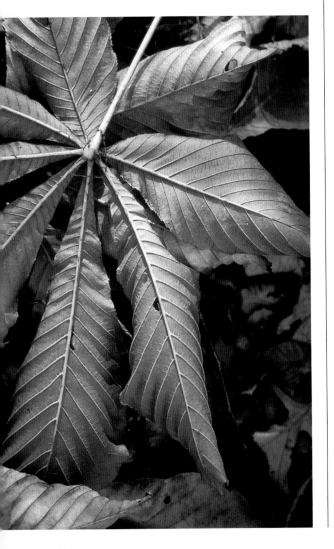

Shoot a number of rolls of black-and-white film and see how certain scenes are rendered in that medium. Black-and-white photography yields rich rewards, and it's worth your while to give it a try.

Scene contrast is as important a consideration with black-and-white film as it is with color film. When working in black and white, however, excessive contrast can be modified with exposure and development techniques and when a print is made. Black-and-white printing paper is available in many different contrast grades, from very low to very high, that allow for both corrective and creative interpretation of negatives. This allows for a wide variety of scene interpretations after the film is processed. In the hands of an experienced printer, the black-and-white negative is like a sketch that can be realized in a myriad of ways. The final print can either emulate the original scene in its full richness of tone or be an entirely subjective interpretation that uses the original scene as a launching pad for a creative journey. For more on black-and-white photography, see my previous book for this series, *How to Photograph the Outdoors in Black and White.*

Contrast

Perhaps the greatest difference in how the eye and film see is in their ability to handle contrast—the difference between the brightest and darkest parts of the scene. Go outside on a bright, sunny day and look around. As you scan the scene, you'll be

Black-and-white photography offers a highly expressive palette and allows us to see design and texture unimpeded by what some consider the distraction of color. In truth, when you shoot with black-and-white film, you may begin to see the world differently. This photograph of a leaf shows the full tonal scale and richness of the medium.

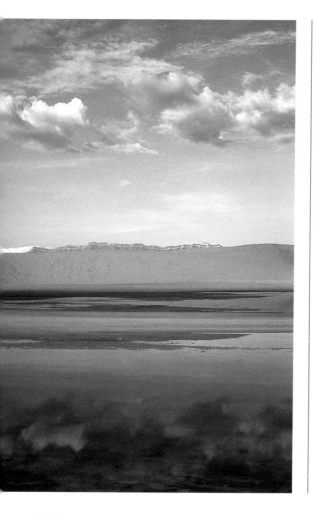

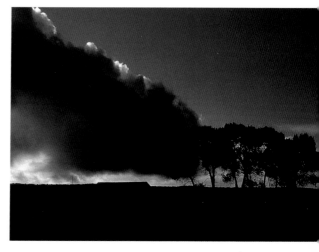

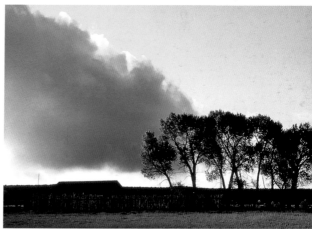

While some scenes seem to be made for color photography, with their rich color content, others are open to interpretation in either medium. Certainly the cool blue tones offset by the tan of the dunes in this scene (above left) make for a pleasant enough color image, but this scene can be equally expressive in black and white. In the end, it comes down to taste and a desire to express a scene in a certain manner.

The scenes at right were made using both color (bottom) and black-and-white (top) film. Both deliver the sense of light in the scene. The slightly darker black-and-white image has a decidedly more graphic appeal. BOTTOM RIGHT PHOTO BY GRACE SCHAUB

able to see detail in both bright and dark areas, such as the sun glinting off the leaves and the rough texture of the tree bark in the shadows. You can see detail in these different areas of brightness because your eyes are in a constant state of adjustment. They constrict and dilate as they focus on different details. The eyes and brain also have a very wide dynamic range and can handle fairly wide extremes of contrast—the

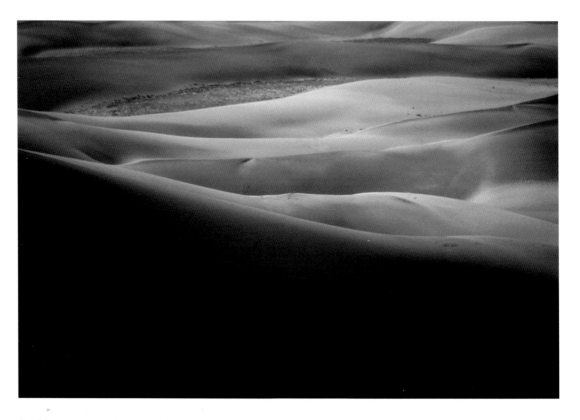

In this scene made in the Great Dunes in southern Colorado, details in the shadow area have been maintained through careful attention to exposure. PHOTO BY GRACE SCHAUB

equivalent of more than eleven stops—in the normal course of seeing.

Film sees only a fixed pulse of light. The meter averages or calculates the brightness values and delivers one set exposure value—a combination of aperture setting and shutter speed—to the film. The difference is compounded when we make a print. Though negative films, as well as digital sensors, have a fairly wide dynamic range, the range of values that can be rendered on a print shrinks to about five plus stops. True, there is leeway in just which five stops can be printed, but in the end that's all we can get out of a print. In addition, prints made by most labs often are made with more contrast than desired and may compress the

tonal scale even more. That's why prints made with care and an appreciative eye always look better than the proof prints from a quick study or from a photofinishing factory.

Slide films have a narrow dynamic range—about six stops. When you use slide film, think of it as making a print right inside the camera. When a print is made from a slide, that scale compresses further; that's why photographic prints made from slides usually exhibit too much contrast and don't match the quality of prints from negative films. When making prints from slides by scanning the slides for computer imaging, however, the contrast and color can be more easily manipulated.

To make effective photographs, you must adapt and make the most out of the situation. If you know that slide film has a narrow dynamic range, you can conclude that images will generally exhibit more contrast than you see, and you might want to exploit that characteristic for more graphic representation of a scene. This realization should make you look at a scene differently. It also points you in a direction of how to expose and compose.

Picture a brilliant fall landscape with sidelight that causes the trees to glimmer and glow. Behind the trees are mountains, and there's brilliant blue sky overhead. When you look with your eyes, you appreciate the light—that's why you want to photograph the scene in the first place—but you also see the trees and rock formations on the mountain. Now that you understand the differences in how the eye and film see, you also observe that there is a good deal of

Print and slide films require slightly different approaches to exposure. A negative, or print film, has an extra chance for manipulation when a print is made. Not so with slide film. If this scene was photographed with print film, exposure would be less critical, and the effect could be created with printing controls. With slide film, careful consideration must be made about placing the highlight values through exposure on film. This is done by exposing for the brighter area and allowing the shadow areas to go darker than they appear to the eye. Seen and exposed with a camera eye, the brilliance of the color is enhanced by its contrast relationship with the darker surroundings.

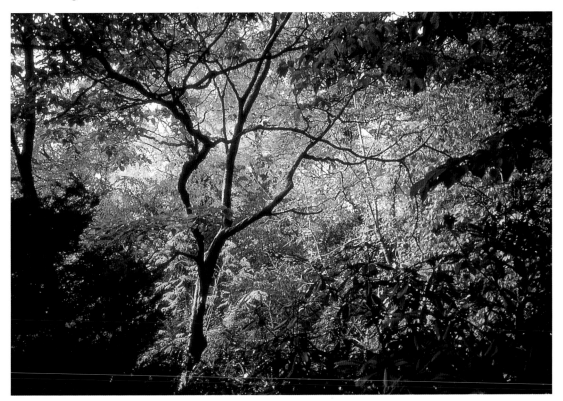

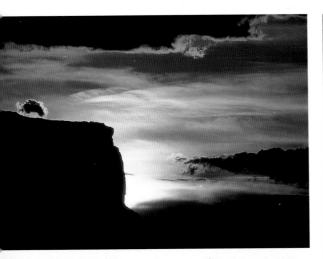

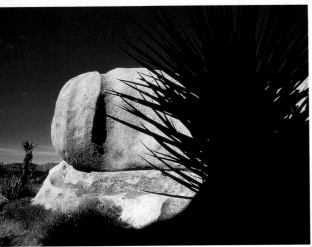

When scene contrast is high, you must often make a choice about the range of values that will be recorded on film. The cliff in this scene (top) was not black, but the aim of the photograph was to record the brilliant sun and beautiful tones in the sky. The brightness difference, or contrast, between the sky and clouds and cliff foretold this result. Any time a bright sky is the main subject—the reason for making the photograph—there's a good chance that the rest of the subjects in the scene will go black, or at least very dark.

This scene in Joshua Tree National Monument (bottom) was photographed in the middle of the day. The boulders were kicking off a tremendous amount of light, but to the eye, the plant in the foreground still had color and detail. I knew, however, that the film could not hold the contrast and that the plant would be a silhouette on film. Rather than resort to fill flash to capture detail in the plant, I decided to let it go black. The silhouette then became a graphic element that enhanced the scene. The key was understanding how the film would react to this range of brightness values and exploiting that characteristic for graphic ends. TOP PHOTO BY GRACE SCHAUB

contrast—about five stops—between the bright light coming off the trees and the mountain. Because slide film exposure must be biased for the highlights, the reading should be made from the bright trees. The mountains will record as a dark, black mass on film. Knowing that you'll have a dark form in the background, you can compose so that the form offsets the foreground light. You view the scene in terms of shapes and forms and masses of light and dark rather than the details, and compose to bal-ance the foreground and background and exploit the play between light and dark.

When you see with camera vision, you understand how what you see will be recorded on film and can exploit the difference between how your eye and film see to make effective photographs. This process is called previsualization. Knowing how to previsualize will influence your exposure techniques and your expectations and will help you consistently capture and enhance the beauty before you in your photographs.

Light Metering

To gain an understanding of light metering, it's important that you begin to see with a "camera eye." Before you get too deep into this section, take some time to walk outside and look around. Notice how the world around you is composed of levels of light and dark and how different surfaces and colors reflect more or less light. Observe how shadows form and how their depth is influenced by the proximity of the subject that forms them. Note the brightness of the prevailing light that creates them. Look at the color of the shadow and how it is influenced by the color of the subject that forms it and the other colors around it. See if there is a pure black shadow or if it contains detail and colors that might not be immediately apparent.

Now look at the brighter surfaces and subjects, and begin to differentiate among levels of brightness. Frame a picture (in mind or, if necessary, through a viewfinder), and locate the brightest subject within that frame. Work your way down to darker subjects. If there is a highly reflective surface, such as light glinting off water or a turned leaf, note whether it's the brightest subject in your view. Observe how subject color and surface texture affect your perception of brightness. If you're near water, take special note of how it reflects light.

Once you've analyzed the framed scene, change your point of view so that the sun strikes it from a different angle. Walk to the side or around the scene so that you're 180 degrees from where you originally stood. You may notice that every time you change your position, the relationship of brightness values also shifts. A tree that was bright and lustrous before has become a silhouette. A body of water that sparkled with light is now a dark mass. Leaves on a tree change from reflective to transmissive subjects.

Seeing exercises are crucial to understanding how a metering system works and how light is translated from the real world onto film. The aim is to understand how light intensity is ordered from light to dark and how brightness values are relative to your point of view. These are the first steps to seeing with a camera eye and gaining an instinct about how brightness values are translated into tonal values on film.

The first stage in controlling light's incredible energy and fitting it into the photographic system is to see light as a scale of relative brightness values. You then identify the range of values you want to or are able to record. Finally, you use your light metering system to place that range within the film's recording scale. Luckily, today's cameras are automated to the extent that you don't have to do any primary work in this regard. The camera's metering system does all, if not most, of the work for you. This ease

and automation do not relieve you of having to see and understand how all this works, however. No matter how automated or sophisticated the camera might be, the way you interpret light—in essence, how you choose the scale of brightness you want to record—is what leads you to make exciting, effective images of the world around you.

Tonal Range

Think of what you'd have to do to make a sound recording of a symphony orchestra. There are bass (dark) and treble (bright) notes of different timbre, levels of pitch produced by different instruments, and highs and lows produced by timpani and perhaps a piccolo. How wide a range of that sound you could record would depend upon the dynamic range of the tape (its ability to record a range of musical sounds), the placement of the microphones, and the way the levels are set on the recorder.

Recording light on film is similar. The ability to record the full range of light depends upon how the film can respond to light (its dynamic range), the way the light is read (the placement of the microphones), and

the placement of those brightness levels on the recording range of the film (like setting levels on a recorder). The aim of both types of recording is to get as full a range of tonal values as possible and to re-create the experience of being there.

There are times when you might want to limit that tonal range by compressing tones

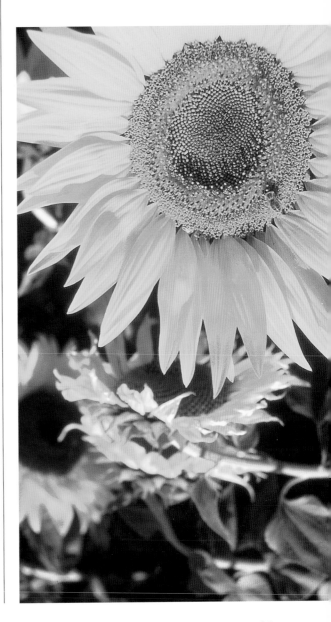

The overall light impression of a scene can be referred to as high key or low key. High key emphasizes brighter values, and low key relies on darker or lower brightness values to set the mood. These bulrushes (left) are lit with a bright, diffused light and typify a high-key scene. Note that though the scene is brightly lit, there is a relatively low amount of scene contrast.

This bold sunflower (right) photographed in southern France shows the effect of a direct point source of light (the direct light of the sun). The petals are the brightest part of a full-scale scene that ranges from textured highlight (the petals of the flower) to mid-tones (the green leaves) to deep shadow.

LEFT PHOTO BY GRACE SCHAUB

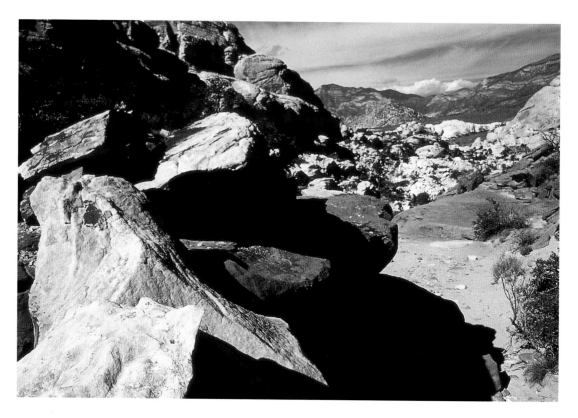

The zone system orders the range of brightness values and helps determine just how they will translate as tonal values on film. Zone 5 is middle gray and becomes the pivot of the tonal values. This scene shows a good range of brightness values. If we lock the shutter speed at 1/125 second and use ISO 100 film, the bright rock on the left reads f/16, the sky and mountains in the background read f/8, and the shadow reads f/2.8. The average of this scene, eliminating the dark shadow from consideration, is f/11. Thus, f/11 becomes the middle value, or zone 5. Being one stop brighter than f/11, the f/16 rock on the left records as the brightest part of the scene. The sky and distant mountains record one stop darker than f/11. This is how brightness values are ordered and recorded as tonal values on film.

and values for artistic ends. That interpretive power is an option with any photograph you make. It can be done when you make the exposure and further refined when you make a print.

In photography, the range of visual notes is defined by something called a gray scale—a range of tonal steps that go from bright white to pitch black. Gray scale is usually used as a way to define black-and-white

tonal range, but it can also be thought of as steps of brightness values in a color image. Within that scale are reference points used as anchors. These anchors determine how the range of brightness values you photograph will record as tonal values on film.

The gray scale is an ordering and organization of brightness values that relate directly to exposure. Each of the eleven steps in the gray scale describes what happens when

you give film another stop of light, with 0 being pure black, 10 being pure white, and 5 being in the middle. Each increase in a step equals what happens on film when you give it twice as much light, or add one stop of exposure. Conversely, each step toward the darker areas equals one stop less of light. These steps are usually called zones, because they describe a range of possibilities rather than one set, absolute value.

Keep in mind that the gray scale is the universe in which all photographs exist. It is a closed loop. It is the context in which all metering calculations are made. It defines the range of possibilities of how light is recorded on film. While each scene and image may have different solutions, or exposures, every exposure is based on how those gray-scale values are placed within the film's recording range.

One of the most important zones in the gray-scale system is zone 5, often called middle gray. This is the tonal value to which all photographic light metering systems are calibrated and the pivot around which all the other tonal values revolve.

This sunset scene on the Monterey Peninsula in California shows the full range of values, from deep black (shadow) to bright white (spectral highlights) and all the values in between. High scene contrast here forced a decision about what tonal range could be successfully recorded. Because the exposure was made to retain the richness in the sky, the rocks recorded only as detailless form. If the exposure had been made to reveal detail in the rocks, the sky would have lost its luster.

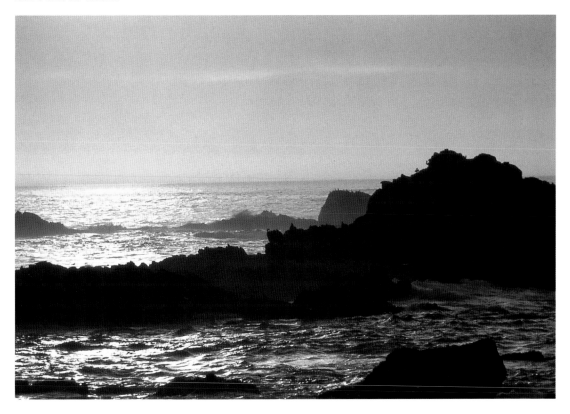

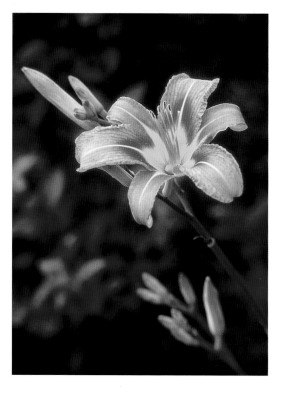

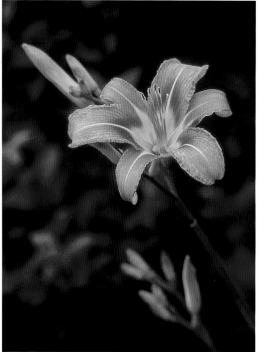

Technically, there are three states of exposure: overexposure, underexposure, and correct exposure. One could argue that there is another state—the exposure that matches your interpretation of a scene. Overexposure (top left) occurs when too much light is allowed to strike the film. This results in harsh highlights, open shadows, and a poor tonal balance throughout. Typically, the correct exposure (top right) is a balanced exposure that takes both highlight and shadow areas into consideration and results in a film record that mirrors the brightness values in the scene. Underexposure (left) occurs when not enough light is allowed to strike the film, resulting in loss of shadow information and, if excessive, loss of color and even midtone quality. The right exposure could be one of these, but it also could be none of these—it is the exposure that effectively communicates what you wish to state about the subject, lighting conditions, and mood of the scene.

Film can record only within a certain range of brightness values. In high-contrast scenes, certain areas will be too bright or too dark to record with detail; they only record with tone. (This is why shadows record as black on film.) Two key terms help identify the darkest and brightest parts of a scene that you can record with detail: significant shadow and significant highlight. Anything darker in the scene than the significant shadow will become a dark mass; anything brighter than the significant highlight will be too bright to show any texture or detail and will be seen as paper white on prints or clear film on slides. Values brighter than the significant highlight are called specular highlights. These read as pure light and may be the glints off water or high reflectivity off sunlit snow.

If you expose in a way that does not capture the scene properly, you're either overexposing or underexposing. Overexposure means that too much light has struck the film to properly record the scene. This may cause brighter areas to lose detail. Underexposure means that not enough light has struck the film. This causes a loss of shadow detail and poor color rendition. In both cases, you will record something on film, but the image will not be a good representation of the brightness values you saw. Either situation makes for poor picture quality.

Imagine a scene of a pond in the woods at sunset. The pond is surrounded by fall foliage with red, green, and yellow leaves. The yellow leaves reflect the most light and are the brightest; thus they are the significant highlight in the scene. The light that

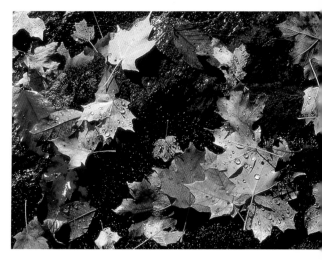

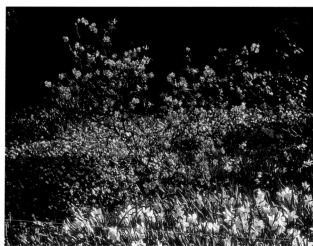

When metering, pay attention to the principal subject. In this scene of fall leaves (top) on a streambank, the only area read by the meter was the clump of leaves—the orange and tan—in the upper left portion of the frame. As a result, the leaves all recorded with texture and detail, the bright areas becoming a middle gray value, while the background became dark.

Similarly, this azalea bush (bottom) bordered by daffodils was sunlit, but the background was at least three stops darker. To retain detail on the flowers, a reading was taken directly from the petals. This resulted in a good exposure of the flowers and a very dark background. If the exposure reading had been made from the background, the flowers, being three stops brighter, would have become overexposed and lost all color value on film.

strikes the water glints off the surface, creating specular highlights. The edge of the pond is surrounded by low bushes, which are lit by reflections from the pond. These are the significant shadow area. Beneath those bushes are deeper shadows. They are too dark and hold no visual interest, so it's acceptable for them to record as dark masses on the film without detail. The range of light that will thus be recorded includes everything we see but is limited in its revelation of texture and detail to those values bordered by the significant shadow and significant highlight—all else is dark shadow or superbright.

Now you need to be able to translate that range of brightness values so they will record with matching tonal values on film. This is where the exposure metering system comes into play.

Exposure Metering

Today's exposure systems are technological marvels. They take the guesswork out of exposure and give you a foundation on which to make creative decisions. Notice I said "foundation." In truth, no meter always gives you exactly what you want. If it did, there would be no reason for you to be on the other side of the camera. You could just send a robot out into the world and let it do your photography for you.

The meter is an objective tool, while your eye and desire for expression usually rely on subjective evaluation of a scene. But once you understand just what information the meter supplies, you can begin to add your own interpretation—or correct for some of the meter's failings—in many types of scenes. That's the real key to successful photography—knowing when to add that personal touch.

To get a handle on this, you need to understand what a meter does with the light information it receives. Most of us use in-camera meters, although some folks feel that an incident, hand-held meter is the way to go. My feeling is that given a bit of understanding, any advantage offered by a hand-held meter is small. The only instance in which an incident meter is an absolute necessity is for studio work with flash. For fieldwork, your in-camera meter will perform admirably.

Here's what happens when a meter switch is activated. The camera's sensitive eye opens to the light in the viewfinder—the area defined by where you're pointing the camera—and takes a measurement of all the brightness values it sees. It then averages those values and places that averaged value at the middle of the film's recording scale, or middle gray. Thus the metering system's job is to tag a value as middle gray and send this information to the camera in the form of an aperture setting and shutter speed. It will do this with whatever it reads, be it a range of brightness values or one brightness value.

It's important to understand how this works. Light is measured and placed on the midpoint of the film's recording range. The metering system does this by either averaging various light values or using whatever light value it sees. Thus, when the meter reads a scene with bright and dark areas, it will average them to middle gray. In-camera spot meters and scenes with one brightness value may generate only one value, which is also placed at middle gray.

In essence, the meter mediates between the two ends of the photographic process—the scene and the film. It is calibrated according to the film's sensitivity to light (indicated by its speed, or ISO), and translates light values to aperture and shutter speed. It does this within a closed-loop system that harnesses light energy to record on film.

When making light readings, there are a number of factors to consider, each of which has an effect on how well the system works. These factors include the metering pattern of the exposure system, the speed of the film in the camera, and just where in the scene light

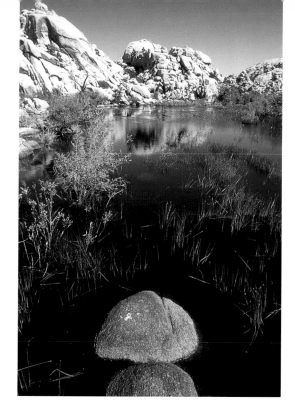 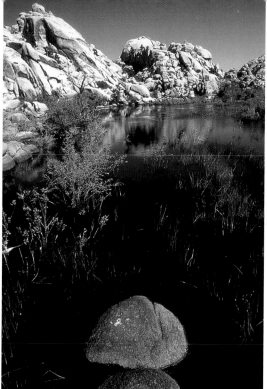

When metering, be mindful of where you point the camera for your light information. In this scene of a desert pond in Joshua Tree National Monument (left), the camera is pointed straight ahead. The meter reading is made off the dark pond. This places that large, dark area in the middle of the recording scale and makes the lighter area too bright. The solution is to raise the camera to the brighter area, take a reading, recompose, and shoot. This places the surrounding rocks in the center of the recording scale, makes the sky a deeper blue, and sets the range of tones in proper order. The darker rendition (right) enhances the grass and lone rock even more.

The higher the contrast, the greater the need to pay attention to the light values of importance in the scene. Here (below left), pointing the camera straight at the scene makes for an averaged reading of the dark and bright areas, resulting in an exposure where the detail between the rows of sunflowers is revealed but the sunflowers themselves are overexposed. A better approach is to take a reading off the sunflowers themselves and to allow the areas between them to go dark.

ALL PHOTOS BY GRACE SCHAUB

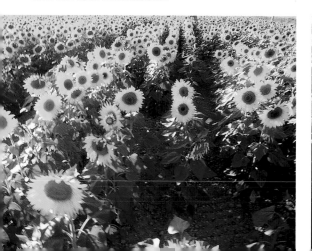 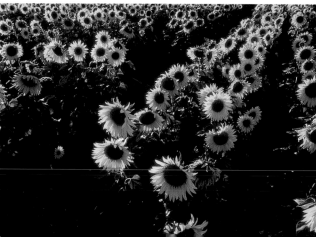

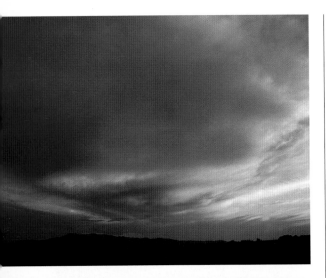

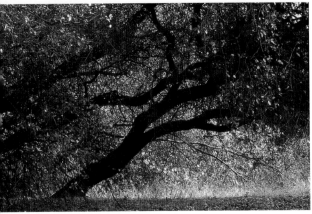

Making exposures of a scene is a two-step process. The first is to decide on the area you identify as most important. The second is to take a reading in a way that translates those values onto film. Here we have two separate value areas: the ground and the clouds. We have to decide which to use as our foundation for exposure. Knowing that the high contrast of the scene will not allow us to record both with detail, we choose the clouds. As a result, the ground goes darker than we saw it in nature. Why choose the clouds? Here, their texture and form make it an obvious decision, but not every scene will offer such an easy choice.

In this case (bottom), the choice must be made to base exposure on the tree or the background. The subject matter and mood make the call. A decision was made to create a silhouette out of the tree trunks and limbs and to use the background light and texture as the context. As a result, the exposure reading was made by walking behind the tree and taking a reading, and then locking that reading and returning to the original vantage point to make the picture. You can lock exposure by reading and setting it manually, or by using the auto-exposure lock (AEL) switch on your camera when shooting in an autoexposure mode.

readings are made from—in essence, where you point the camera to make a reading.

The most typical light-metering pattern—the one found in virtually every through-the-lens metering camera—is center-weighted averaging. Let's look at how it arrives at a correct exposure.

Say you want to photograph a sunlit scene that contains blue sky, white clouds, and well-lit trees. The framing creates a fairly equal distribution of highlights (the clouds), middle values (the blue sky), and darker values (the trees). You fix the shutter speed value at 1/125 of a second so the aperture reading will change according to differ-

ent brightness values. Before you make an overall reading, you point the camera at the clouds. Being brighter, they read out at f/16. The trees, being darker, read f/8. The blue sky, in the middle of the two in brightness, reads f/11. If you average the three values, you come up with f/11, which is the correct exposure. Now you point the camera at the entire scene, and lo and behold, that's the reading the camera metering system comes up with as well. The meter does the job of averaging the values for you.

Now here's how the brightness values in the scene record as tonal values on the film. Because f/11 is the exposure, that's the

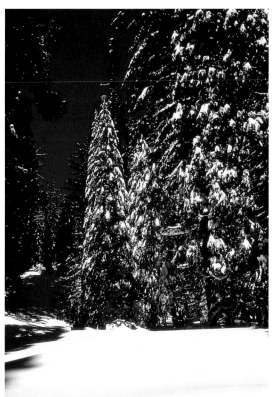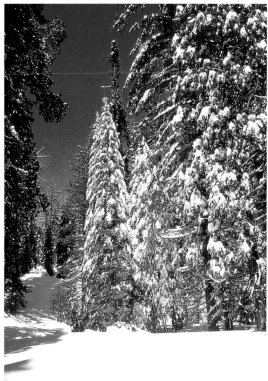

Exposure compensation is made for corrective or creative reasons—corrective to overcome meter failures when reading very bright or dark dominant areas, and creative to add a personal touch to scenes. Snow presents the most common bright-field dominance problem. The first exposure was made at the camera-recommended reading. Because the snow was bright, and because the meter is calibrated to center values at middle gray, the result is gray snow and underexposed trees. The camera was then left on autoexposure, and exposure was compensated plus one and a half stops. This used the exposure reading as a foundation and took into account the effect of the bright snow. The result is white snow and well-exposed trees.

value that's placed at the middle of the film's recording scale. Thus, at f/11, the blue sky records as the middle value. At f/16, the clouds are one stop brighter, and at f/8, the trees are one stop darker; they will record as such on the film. By averaging, the camera's metering system places and records all the brightness values correctly, and the tonal values on the film mirror the brightness values in the scene.

For images where the brightness values are varied—there are light and dark parts of the scene—and where they are distributed evenly throughout the frame, most camera meters will yield a correct exposure. That scenario may cover 60 percent of the photographs you make, although you may, and should, try to interpret the light in some scenes. In those cases, the meter reading will serve as a foundation for your creative input.

Another influence on correct exposure is the area in the scene at which you aim the camera and thus take the light reading. Recall the analogy of the recording session with the symphony. Think of making that recording and placing your microphone in the middle of the flute section or underneath the kettle drum. If you have only one microphone, you'll want to place it so that all the orchestra is recorded, and not just one section. The same goes with light meter readings. To get the best result, the camera should be aimed at the areas that will feed the proper light information to the meter. This may seem obvious, and in many cases you'll get a good exposure just by framing your scene and shooting. There are other times, however, when the obvious doesn't apply or when a bit more attention to the light play in the scene will make a big difference in results.

Let's say you're photographing a field of brightly lit flowers against a dark background. The light striking the flowers is quite bright, and the petals blaze with color. You compose so the flowers sit in the lower horizon of the frame and the dark woods domi-

Even when shooting snow on overcast days, you can compensate exposure to gain a better result. This exposure (top) was made using automatic exposure mode and compensating plus one stop. Though we can't change the basic lighting conditions, we can sometimes improve on it with exposure compensation.

In some cases we compensate solely for effect. This tree in bright sunrise fog (bottom) would have recorded considerably darker with a straight center-weighted autoexposure reading. Compensating plus one stop added to the glow. If you're not sure how compensation will affect a scene, experiment with tricky lighting situations until you get a feel for what adding and subtracting light from the meter reading will do.

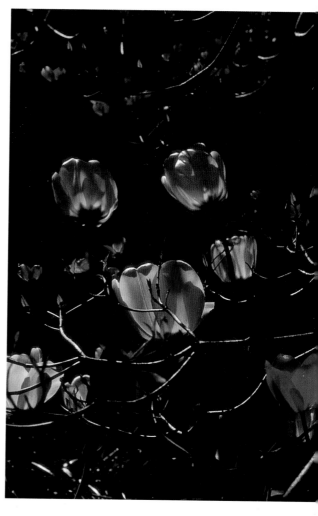

Dark-field dominance can be corrected or enhanced through exposure compensation. When a meter reads such a scene, it has a tendency to make the dark area lighter. This often results in poor picture quality and goes against the creative intent of the photographer. These lily pads in a pond (top left) are fairly well exposed, but the dark mass of the pond nudged the meter to add light. This lessened the color richness of the pads themselves. Seeing that dark field, you should automatically think of what it will do to exposure, and compensate accordingly. At bottom left, a minus one stop compensation was applied.

You can also use this technique to purposely darken a scene to highlight brighter subjects. Above right, a group of tulips caught the late-afternoon light. The background was darker than the tulips but not as dark as appears in this image. To gain this effect, a reading was taken of the entire scene and then was compensated minus one and a half stops. This sacrificed some of the detail in the tulips but made the background go near black. Another way to create the same result would be to make a reading solely from the tulips. Your technique depends on your equipment and perhaps even your ability to approach the subject to make the reading from it. PHOTO BY GRACE SCHAUB

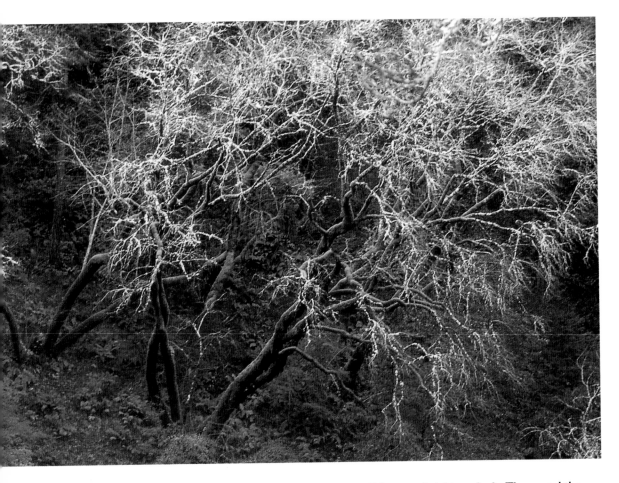

Meters are indifferent to light levels and do not see conditions as bright or dark. They read the light and translate those values to aperture and shutter speeds, even in the brightest or dimmest light. The result is that the recommended exposure in a low-light scene may pump light into it and make the image appear quite a bit brighter than seen by the eye. This hillside in Napa Valley, California, was photographed right after dawn in very low light. The reading was f/4 at 1/8 second. The camera was steadied on a tripod so that there would be no camera shake at such a slow shutter speed. The camera exposure reveals more than was seen and remembered by the eye.

nate the picture space. Because the meter averages the light values and brings that average to a middle gray, when it takes in the large area of darkness it will lighten the background, moving it toward middle gray, and subsequently overexpose the flowers. Exposure and metering work in lock step—you can't selectively add or subtract exposure from parts of the scene when the photograph is made. You can do this later when prints are made from negatives, but this extra step is available only if you do the work yourself or pay a custom lab to make the prints. With slide film, there's no way to redeem the light values on the flowers later. Overexposure of slide film means loss of details and color.

The key is to recognize the situation and understand how the meter reads. Then you'll know when to make exposure adjustments that place the light values where you want them on the film's recording scale.

The solution to the bright flower, dark background scene is to take a reading right off the flowers. You then lock that reading, with autoexposure lock or, in manual mode, by setting the aperture and shutter speed values yourself, and then recompose and shoot. This will place the flowers in the middle of the recording range. Placing the flowers in the middle will cause the darker areas to go darker still on the film, but this is OK, as the most important part of the scene is the flowers. Deepening the tone of the dark areas may, in fact, enhance the entire image.

Conversely, let's say you're photographing a juniper tree against a bright sky on the edge of a canyon wall. You want to record the beautifully textured bark of the tree and use the background as a frame. If you take a reading of the entire scene, the brighter background will dominate and cause the tree to go dark on film.

This lighting condition, known as backlighting, is the chief culprit in outdoor photography problems. It is sneaky, because our eyes can see the detail in the bark and handle the brightness of the background at the same time—or at least, we can appreciate both in an instant—but the film can't. The high-contrast condition precludes proper rendition of the scene on film, and some sacrifice must be made.

If you want to record the tree as a silhouette, you can shoot away. If, however, you want to have detail in the tree, you have to move in and take a reading off the tree itself, lock the reading, move back and recompose, and shoot.

Backlighting can cause major problems in landscape scenes. It may cause a loss of color richness in the sky or underexposure and loss of detail in the foreground. The key is to recognize the problem, take the reading off what is most important in the scene, and understand that in higher-contrast situations you may lose some details in either the brighter or darker parts of the scene. This can be used to your advantage if you know what to expect. If you don't, you'll usually be disappointed with the results. You may be able to get around this by waiting for the right light or by changing your point of view to reduce the contrast between the sky and the ground.

Most of us understand disappointing results, but how can we use difficult lighting situations to our advantage? Let's say you're photographing some colorful, sunlit leaves in a stream with slide film. When you look at the potential picture, you see dazzling colors and rich details in the leaves. You go ahead and take the picture with the reading recommended by the camera, but the resulting slide has weak color caused by overexposure in the bright or highlight areas. What happened? The meter averaged the light values between the dark stream and bright leaves and left you with neither the colors as you saw them nor the richness you envisioned when you pressed the shutter release. The poor results come from a failure to see like film and understand how the meter performs. To obtain good results in this situation, you need to meter off the leaves themselves and eliminate the darker streambed from exposure consideration. The result will be rich colors that may be even more startling than what you originally saw.

Let's consider another scenario. You take a photograph of a brilliant sky towering over a mountain range. You get some details in the mountains but lose the depth and drama of the sky. Remembering that under such lighting conditions you may have to sacrifice some detail in a part of the picture, the best approach is to allow the mountains to go darker in order to retain and even enhance the dramatic sky. You do

The "correct" exposure depends on how you want to render a scene. These cypress knees in the Everglades were illuminated by bright, directional light. A spot reading was made right off the bark, making the shadows in the background, and all the detail they held, go black. More exposure—or the exposure recommended by the camera's center-weighted meter— would have revealed more details but would have diminished the overall graphic effect. PHOTO BY GRACE SCHAUB

this by pointing the camera at the sky, locking in your reading, and then recomposing the scene and exposing at that reading.

In essence, knowing how a meter works makes you see differently and causes you to make choices that can only benefit your photography. The medium does have its limitations, but understanding those limitations and exploiting them for effect will yield the most exciting photographs you have ever made. Anyone can photograph in "friendly" light, but being able to meet the challenge of difficult lighting conditions often makes for the best photographs.

Exposure Biasing

While translating light through judicious exposure reading is something that comes with consciousness about film and light and with experience, a good way to begin is to follow this general rule: Bias your meter reading off what is most important to you in the scene.

Let's say you're photographing a sunset scene on the shoreline. You're using the shore as a compositional balance, but you're not too concerned with recording every detail on the beach. To get the full impact of the sunset, tilt the camera slightly skyward and lock the reading, then straighten out the horizon line in the composition and shoot. The meter will read only the brighter sky, and its colors will be enriched on film.

For another example, you're now photographing in the Great White Sands National Monument in New Mexico. The white sand is lit brightly by directional light, and a dark sky looms in the distance. You want to maintain texture on the sand and deepen the sky. Here, you tilt the camera toward the sand to make the reading, keeping some sky in the frame, and then recompose and shoot.

How you should bias your reading depends upon whether you're working with negative or slide film. The general rule is that with slide film, you should bias expo-

sure toward the highlight; with color or black-and-white negative film, you should bias the exposure toward the shadow, or darker, areas.

Let's say you're photographing in the canyon country and come across a beautiful pattern on a rock face. The light plays over the face of the stone, and lighter areas offset the deep red tones. To nail the exposure on slide film, you have to make sure to include a good portion of the brighter areas in the viewfinder when making the exposure reading, regardless of the final composition. Fail to do this with slide film, and the texture of the brighter areas could be lost or washed out. If you expose by biasing for the highlights, you'll probably get deep shadows that are considerably darker than you saw in the original scene. But that's the price—and at times the charm—of using slide film.

With negative film, you could put an equal amount of the shadow and bright area in the frame for your exposure reading. Unless the image area has excessive contrast—five or more stops—you will usually record virtually all the light values on film. If the brighter areas become overexposed, you can have them printed darker later.

There's a trick for recording excessively high-contrast scenes with black-and-white film. Here, you meter the shadow area in which you want detail (the significant shadow), and subtract two stops from the reading. This ensures that you will record the shadow detail. This works only if you shoot the entire roll in this way, and under similar lighting conditions, and then subtract about 20 percent from the developing time. Failure to decrease the developing time may result in excessive, harsh highlights. One of the maxims of black-and-white photography is to expose for the shadows and develop for the highlights. This technique gets as much tonal information as possible on film and tames contrast by decreasing developing time.

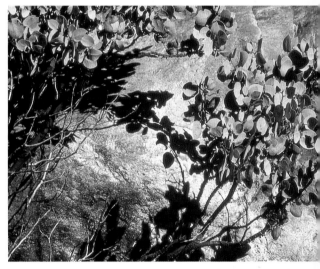

You can change the mood of a scene by playing with exposure controls. Adding exposure makes subjects lighter, resulting in a pastel rendition of colors; subtracting exposure deepens color and contrast, and creates a more graphic effect. In the desert scene at top, plus two-thirds stop was added to open shadows, brighten colors, and communicate a sense of the glaring light.

Subtracting two-thirds stop from the bottom scene deepens shadows and makes for rich, saturated colors.

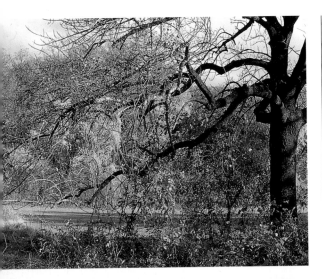

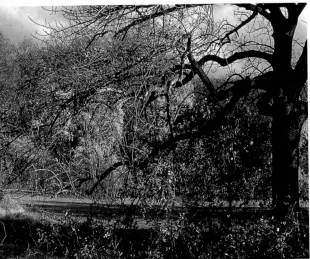

While the essential rules of exposure apply to all types of film, there's a different way to approach creative controls with slide and print film. When you expose slides, you are, in essence, making a print within the camera, as the slide is the master of the exposure. Print film—color or black and white—results in a negative that is later made positive via a print. That extra step allows for a number of creative controls and corrective steps. Here are two renditions of a fall scene. Most of us would choose the darker version as showing more color richness and a better graphic effect. If you were to expose this scene with slide film using a center-weighted metering pattern, you would make the correction by overriding the exposure in the camera minus one stop when you snapped the shutter. With print film, you could use the camera-recommended exposure and forget about compensation. After you receive the first set of prints (or in the darkroom yourself), you could use the negative to make a darker print. When shooting slide film, pay close attention to creative controls, and train your eye to apply them on film, especially if you plan to use your slides for projection or want to submit them for publication. When shooting print film, get the best exposure you can, but understand that you have a second chance to make more creative and corrective decisions later.

Spot and Evaluative Metering Options

Some cameras have an optional metering pattern known as spot, or partial frame, metering. This limits the reading to the very center portion of the frame and is usually indicated by a small circle in the viewfinder. Spot metering offers a more precise reading of specific values and can be a true friend in difficult exposure situations. It does, however, come with the added responsibility of understanding that a single point reading may have to be modified to obtain correct exposure for the overall scene.

Because the metering system places whatever brightness values it receives at the middle point on the film's recording scale, if that information is restricted to one brightness value or area, then that value is placed at middle gray. This allows you to make exposures by picking which brightness area you want at middle gray or by choosing a highlight or shadow area and compensating accordingly.

Think of your initial exposure as a sketch that can be refined later when you make a print. Whether you work in a conventional darkroom, with a custom lab, or on a computer after scanning your images, there are many ways to reinterpret images after the initial exposure. At left is a straightforward photograph of a pine tree with a consistent light playing over the needles. While the shapes are interesting, there is no center of light or one form that grabs the eye. Later, in the darkroom, the edges of the photograph were burned in (given additional selective exposure) to enhance a form in the center (at right). Note that this is one approach; any number of choices could have been made.

Let's look at a couple of examples. Say you're photographing fall foliage with slide film and want to emphasize the brilliance of light on a cluster of leaves. You aim the camera at the leaves and place the spot in the center of the viewfinder over the main cluster. You lock in the exposure and shoot—the result is a perfect exposure of that quality of light you seek.

You then turn your attention to the entire tree and move so that the light is coming through the leaves toward you. This causes the tree trunk to be backlit. You take a reading so that the spot target falls on the tree trunk. This provides an exposure where you can see every detail on the tree bark. The rest of the scene—the backlit leaves, sky, and so on—becomes grossly overexposed. What happened? The reading was based on the darkest part of the scene. The spot meter restricts the angle of reading to just the area it covers. The darkest area—the tree trunk—was placed at middle gray, and all the other brightness values were driven up into overexposure.

Therefore, when working with the spot-metering option, you need to be careful to place the spot over the area you want to record as the middle value. In the first shot, the spot meter was aimed right on target; in the second shot, the camera was used as if it were recording with a center-weighted metering pattern, forgetting that the only reading you were getting was from the center of the tree trunk. This does not mean that the spot meter should be shunned; you need to know how to compensate for proper exposure.

Other options available in modern cameras are evaluative, matrix, or intelligent metering patterns. These patterns break up the image into five or more zones and make exposure calculations based upon the dispersion of light values within each of those areas. The microcomputer in the camera calculates the exposure by comparing the distribution of light in those areas with preprogrammed exposure scenarios and arrives at what it considers a good exposure. These impressive systems can be relied on in many situations and may, in some instances, eliminate the need for exposure compensation. They can't, however, think and feel for you, and won't always give you the results you desire. If you have one of those options, try it out in a number of lighting conditions. It can't always solve problems of excessive contrast, eliminate flare, or deliver artistic interpretations in tricky light—in other words, it can't deliver results beyond the capabilities of the optical system or the film.

Exposure Compensation

With both center-weighted and spot metering, there are times when you'll have to become involved in the calculations for a correct exposure. These instances are called meter failures and are caused by the very nature of how the metering system works. The fact that the meter averages the reading to the middle of the film's recording scale will cause problems when the entire frame is dominated by very bright or very dark values.

The classic bright dominance problem is sunlit snow. The extreme brightness of the snow dominates the scene, and the subsequent exposure reading, or may be the only value within the scene. The exposure meter yields a reading that places the brightness at the middle of the recording range, thus reading the white snow as gray on the film. To counteract this, you have to override or compensate the exposure. To go from gray to white, you need more light, so you need to add exposure to what the meter recommends. You can do this with the exposure compensation dial on the camera or, in manual exposure mode, by adding a stop or more using the aperture or shutter speed controls. Add one stop for bright snow, or

one and a half stops for very bright snow on a brilliant winter day. To add a stop using the aperture, open it up wider—for example, from f/11 to f/8. To add a stop with the shutter speed values, slow the shutter speed down by one stop, say from 1/125 to 1/60 of a second.

I was once on a shooting trip with a number of photographers high up in Engineer Pass in Colorado. We came around a corner in our four-wheel-drive vehicle, and the driver put on the brakes. The sun was shining brightly on a beautiful, snow-covered mountaintop in the distance. As we jumped from the Jeep, we all shouted: "Plus one and a half!" That meant that all we needed to do was set our exposure compensation dials at plus 1.5, and we could shoot away in the autoexposure made without the need to worry about adding or compensating exposure to the meter-recommended settings.

Another compensation is required for dark scenes in which you want to retain the mood right on the film (although when shooting black-and-white or color negative film you can let the meter do its thing and then make the scene darker when a final print is made). Let's say you're photographing ferns on the forest floor. When you make a reading, the meter yields f/5.6 across the entire scene. Yet you know now that the meter takes in light and averages to a middle gray, probably yielding too light a version on film. Here, you want to make the recorded scene darker, so you need to subtract light from the exposure. Depending on how deep you want to set the mood, you can take away from two-thirds to one and a half stops with slide film by using the exposure compensation dial or manually setting the new exposure.

Once you understand how the meter works, it should begin to make sense. You're not subtracting light from a dark scene; you're moving the tonal values of the scene on film from a medium (or lighter) to a

darker rendition. You're not adding more light to an already bright scene; you're moving the tonal values from gray to white. The ability to shift and manipulate light values lies at the heart of interpretive photography and is an important part of seeing with a camera eye.

The best way to understand this is to try it yourself in a variety of lighting conditions. Load a roll of slide film, and go out in the snow on a sunny day. Working in autoexposure, photograph some of the roll without setting compensation and the rest of it at a setting of plus one stop compensation. On a hike into the woods, find a shady scene. Photograph it with the meter's recommended reading, and then subtract exposure for comparison. Try other situations: Subtract light from the reading on an overcast day or add it on a bright day at the beach. Knowing just how much compensation to add or subtract comes with experience and varies according to the mood you want to set. You'll learn the difference between a plus one and plus one and a half stop compensation only by trying it out under different lighting conditions.

Exposure Bracketing

Perhaps the quickest way to understand how exposure affects the overall lighting situation and how it can be used for nuances of expression is to make what are called exposure brackets in a variety of scenes and situations. Bracketing means making exposures plus and minus from the camera meter's recommended exposure. For example, say you are photographing a field of yellow flowers lit by a clear sky. With slide film loaded, take a reading; say that reading is f/8 at 1/125 of a second. Lock the shutter speed setting, and bracket by changing the aperture. Shoot the scene at a plus and minus two-stop bracket in half-stop steps, at f/4, f/4$^{1/2}$, f/5.6, f/5.6$^{1/2}$, f/8, f/8$^{1/2}$, f/11, f/11$^{1/2}$, and f/16—nine shots in all. Put all the slides on a

light box, and see just what effect is had by bracketing. Do the same with a dark scene. If you prefer to use negative film, bracket by full stops and have prints made to see the results. This will create a catalog of effects for you and will help you previsualize the implications of exposure changes under varying conditions.

Bracketing also comes in handy in tricky lighting situations or when you feel unsure about just what exposure to use. It's perfectly legal; in fact, it's a well-kept secret that pros bracket like crazy to get just the results they desire.

The following table lists some typical scenes in which exposure compensation comes in handy. These exposure compensation techniques are corrective; that is, they counteract the way the meter reads the scene and help you capture the light values properly on film. Use these techniques when shooting slide film. When shooting negative film, remember that dark field conditions can be corrected when prints are made. With both slide and negative film, however, bright field conditions will always be helped by compensation.

There are also creative exposure compensation techniques that can be used to saturate color, add a graphic effect, or emphasize a particular subject, light effect, or part of a photograph. These interpretive choices come from experimentation and experience. They use the meter reading as the starting point for departures into mood and interpretation. You can also alter color through the use of filters and even polarize light if you wish. But for now, let's look at how you can alter the intensity of light and color through exposure.

The first step in interpretation is to understand what the light meter does and where to point it when making a scene reading. The next is to have faith that the light meter will do its job. From there, you can begin to make judgments about how you want to play with the light.

Think of the quality of light in your scene—the color, brightness, direction, mood—as something you can enhance. Think of color and light as would a painter who mixes color for a canvas. There's a simple rule of thumb: To intensify color and deepen the mood, subtract exposure; this will also increase contrast in an already high-contrast scene. To make color lighter, for a pastel or high-key effect, and make the image more ethereal, add exposure. This exposure is added to or subtracted from the foundation reading—that which your metering system recommends.

Let's consider a sunset. Generally, we're attracted to sunsets because colors are deep and intense and the sky offers an infinite variety of patterns and forms. But when the meter reads the sky and ground, it has a tendency to lighten the overall exposure. What you see in the final print or slide does not match the breathtaking intensity you remembered. The best way to ensure that

Condition	Typical Scenes	Compensation	Result
Bright field	Sunlit snow; bright beach	+1 to +1.5 stops	True rendition of bright values
Dark field	Forest floor; overcast sky; fog on a riverbank	–1 to –1.5 stops	Retention of the mood of the original scene

the sunset records as you remember it is to subtract exposure from what the camera reads. How much to take away depends upon the scene and the desired rendition—a stop for a deeper sky, and up to two stops for a dazzling result.

Conversely, consider a scene where a tree hangs over a stream. The leaves and water create an ethereal feel. By adding light, you enhance the effect and create pastel colors that are lighter than you remember. In essence, you have taken in the scene, run it through your mind, and made a decision about rendition realized through use of exposure.

This approach recognizes the difference between the "correct" exposure—the one that a technician would say is correct—and an interpretive exposure, one that satisfies an aesthetic sense about the moment. The artistic or interpretive approach is generally the most satisfying. The image can become your personal expression of a sense of place rather than a documentary recording of the scene. That's what light reading should be all about—a way to personalize your photographs that enhances the subject matter and mood of the scene.

The next time you find yourself in a place that inspires you to take pictures, try an easy experiment. Make an exposure at your meter's recommended setting, then bracket plus and minus from that reading—by half- or one-third-stop steps with slide film, by full-stop steps with negative film. When you get the slides or prints back from the lab, line them up and inspect them or, better yet, share them with someone and ask his or her opinion. What is picked as the best or most exciting is not always going to be the frame from the camera-recommended exposure, especially if it's a dramatic scene. Your involvement may require more understanding and be more challenging, but it's also more rewarding. Although the metering system does its job and gets you in the ballpark

of good exposure, more often than not it's up to you to take the next creative step and add something from your knowledge and experience that will take it further. You'll also learn when you should keep your hands off what the exposure system delivers. The main reason for understanding light metering is to have the ability to always come home with satisfying photographs of what first inspired you in the field.

Influencing Light with Selective Focus

Focusing and exposure are separate functions. Exposure techniques are used to ensure that the light in the scene is recorded the way you want it. Focusing techniques determine what will be sharp and unsharp in the picture space. But focusing can also be used as a light-shaping tool. The way you focus and your use of depth-of-field techniques are another way to interpret the light in a scene.

The difference between sharpness and unsharpness in an image can be described as the difference between points and circles of light. When something is in focus, the light rays emanating from it enter the lens, refract, or bend, and converge at a point on the film. When something is unsharp, the light from it enters the lens, bends, and converges either before or after the film plane. Thus, it forms a circle of light rather than a point.

We tolerate certain levels of unsharpness, depending on the diameter of the circle formed by the light at the film plane. We see subjects within that tolerance as sharp. Beyond a certain diameter, or when that diameter becomes expanded through enlargement when bigger prints are made, we see unsharpness. That's why something may look sharp in a small print, only to become unsharp when we enlarge the print. This also depends on the distance from which we view the print—we resolve less

While exposure and focusing are generally considered separate elements, at least on a mechanical level, selective focusing techniques can shape the way light and color are formed on film. The shape of the sun and the background petals on these magnolia tree blossoms are a direct result of minimizing depth of field by working with a wide-open aperture, getting close to the subject, and using a telephoto lens.

from greater distances, so, for example, a 16×20 print of a slightly unsharp photo may look sharp from 8 feet away, only to become unsharp when we examine it closer.

The illusion of sharpness is created by working with something called depth of field, also known as zone of sharpness. That

depth of field is determined by three factors, each having fairly equal weight:

1. The focal length of the lens. The shorter the focal length (28mm versus 110mm, for example), the greater the potential depth of field at any camera-to-subject distance and any aperture setting.

2. The aperture setting. The narrower the aperture setting, the greater the potential depth of field at any camera-to-subject distance and any given focal length.

3. Camera-to-subject distance. The greater the camera-to-subject distance, the greater the potential depth of field with any given aperture and focal length.

The converse of each of the above rules of thumb also applies: The longer the focal length, the wider the aperture, and the closer the camera-to-subject distance, the less the potential depth of field. Depth of field increases with a narrower aperture because the angle of refraction of passing light rays is more constricted (less acute), and thus their convergence at the film plane from varying subject distances is more likely.

All this allows us to manipulate the shape of light itself. When we maximize depth of field, we make everything sharp from close to far and see edge definition. But when we minimize depth of field, we create circles (or blobs) of light, soften edges, and change the way we might otherwise see form, color, and line. This allows us to change a mass of leaves, for example, from a hard-edged set of shapes to masses of color, or flowers to circles of colorful light.

Working with Filters

Placing filters in front of the lens will alter the character of the light passing through it. In some instances, this will equalize the differences between how film and the eye see; in other cases, it exaggerates the differences for creative or corrective reasons.

Filters can be divided into a number of categories: lens protecting, color correcting, color balancing, contrast controlling, light reducing, light enhancing (diffusion or diffraction), and special effects. There is also a filter for polarizing light. The filters we'll look at here are for basic contrast and light control. Special-effects filters, those that completely alter the look of a scene, are best left to other subject matter; natural light in and of itself holds plenty of surprises.

If the camera and lens work with through-the-lens (TTL) metering, no exposure correction is required when a filter is used. If light metering is done with a hand-held meter, a filter factor must be applied to the

Filter Type	Use
Color correcting (CC)	To add a slight color bias to a scene
Contrast control	For black-and-white photography, to pass or block various colors. These can be used to deepen sky contrast or to differentiate subjects that would otherwise record with the same tonal value on black-and-white film.
Light reducing, or neutral density	To decrease the amount of light coming through the lens, usually for slow shutter-speed techniques
Polarizing	To reduce or eliminate reflections or deepen sky
Split contrast	To balance light values in scenes where the sky and ground are of greater contrast than can be handled by the film

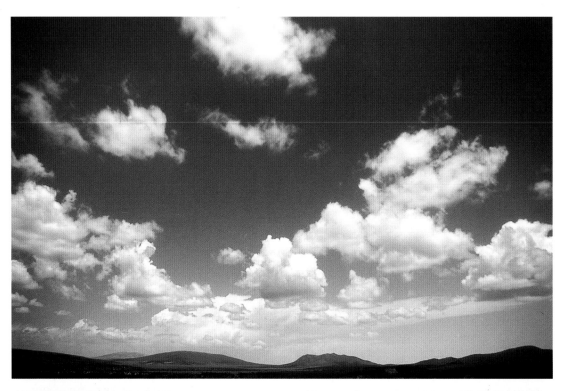

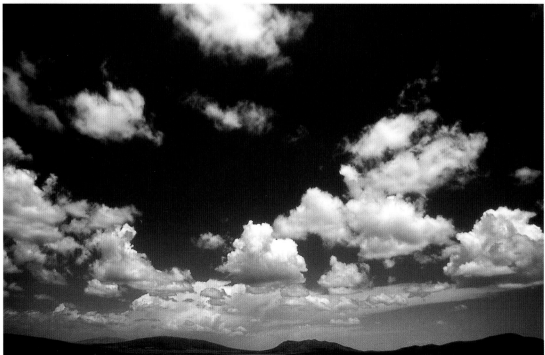

exposure. The filter factor is supplied with the technical specifications that accompany the filter. This factor requires you to add a stop or more to make up for the loss of light transmission caused by the density of the filter.

I recommend the use of filters more with black-and-white photography than I do for color photography. This may sound odd, but consider that with black and white you are working with the brightness value of color and not the color itself. Filters help differentiate color and enhance scene and subject contrast. They are key in manipulating how tonal values relate to one another on film.

Color filters pass and block color light. The filter passes its own color and blocks its complement and, to a certain extent, other colors. If you take a picture of a subject including green and red without a filter, you may have trouble differentiating between the two in a black-and-white print. However, if you place a red filter over the lens, it will pass the red light reflected from the subject and block the green. Thus, the red will receive more exposure than the green, show more density on the negative, and print lighter than the green. Try this yourself, and you'll see that it's true.

When using color filters for black-and-white photography, we are affecting the contrast via the change in the way color from the scene is rendered. Thus, these filters are often called contrast-control filters. Color filters are often used in black-and-white landscape photography to affect the sky rendition. If you're photographing a landscape with billowing clouds racing across a deep

Natural light provides so much variety that there's rarely a need to use filters. One filter that can come in handy for color photography, however, is a polarizing filter, used to enhance sky and clouds in the bottom photo.

blue background, you should reach for a red, orange, or yellow filter. If you photograph without a filter, there's a good chance that the blue of the sky will record slightly lighter than you might have desired. Because some panchromatic films are oversensitive to blue, it records with greater density than what we see in the rest of the scene, and thus prints lighter than you might like. To deepen the blue, increase sky contrast, and add drama to the scene, place a yellow filter over the lens; this blocks the blue color by decreasing some of the density, thus deepening the blue impression in the print. Use an orange filter to increase the effect, and a red filter for even more effect. The red filter yields an almost black blue that can be very dramatic, although it may be overdoing the effect in some scenes.

If you're photographing a green leaf, a green filter will accentuate the contrast, yielding more visual emphasis to its design. Use a red filter to photograph a forest, and the green leaves on the trees will become quite dark. In short, a filter will cause subjects of its color to appear lighter and complementary colors to appear darker. The following table shows the effects of various color filters in black-and-white photography.

Filter	Darkens	Lightens
Yellow	Blue	Red, green
Green	Red, blue	Green, yellow
Red	Blue, green	Red, yellow
Blue	Yellow, red	Green, blue

A red filter is an absolute necessity if you are working with infrared film. Because the film is sensitive to infrared as well as all other colors, the red filter tends to block the other colors and pass the red and infrared light in the scene.

One filter that's useful for both black-and-white and color photography is a polarizer.

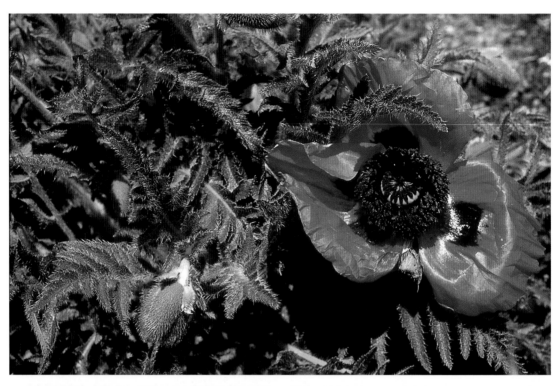

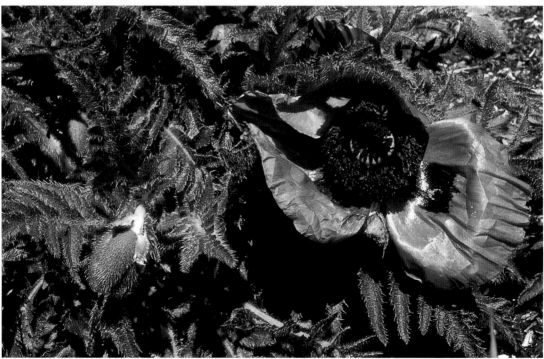

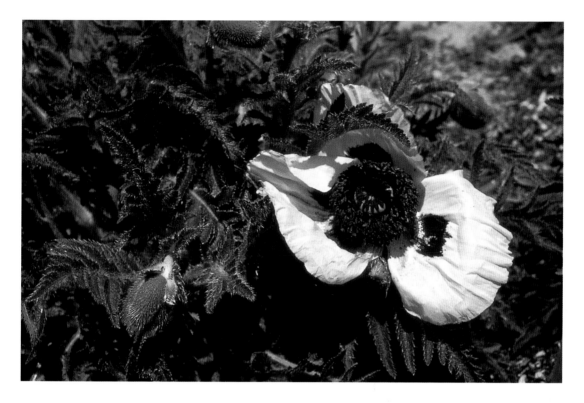

Black-and-white photographers should study the effect color filters have on color and contrast rendition. This poppy was photographed first with color slide film (top left), then with unfiltered black-and-white film (bottom left). Note that in the unfiltered shot, the brightness of the red flower and green plant is similar, and they have the same tonal value on film. There is no way to tell that the flower is red. When a red filter is placed over the lens, however, it transmits all the brightness of the red flower and blocks the green, making it darker on film (above). Now we see a startling differentiation of light and dark tones.

This has no color effect but works on the direction of light reflections. It can be used to eliminate surface reflections from water, deepen sky renditions, and reduce the harsh glare off sand. Polarizers are actually two pieces of polarized glass mounted in a filter frame. As you turn the outer glass mount, you see the effect of the filter right in the camera viewfinder. This allows you to previsualize the degree of polarization. The filter is colorless and will have no effect on overall color cast. Some cameras and metering systems require the use of a circu-lar polarizer rather than a linear polarizing filter. Check your instruction manual for the one to use.

Neutral-density filters also have no color effect. They are used to cut down the amount of light coming through the lens. Let's say you're photographing a river or waterfall in bright light and want to use a very slow shutter speed to emphasize the motion effect. Generally, a shutter speed of 1/8 second or slower will turn rushing water into a smooth, flowing mass. When you take your exposure reading, however, even at

This forest scene was photographed unfiltered (left), with a yellow filter (center), then with a red filter over the lens (right). Note how the yellow filter deepens the blue of the sky and brings tonal richness to the leaves. The red filter almost darkens the blue sky and makes the leaves turn quite a bit darker.

your minimum aperture—the narrowest opening your lens affords—you still come up with a shutter speed of 1/30 second. To get to 1/8 second, you have to lose two stops of light. You could switch to a slower-speed film, but that's not always possible. If you place the proper neutral-density filter over the lens, you can cut down the light and get the shutter speed required. Neutral-density filters come in various powers, with higher numbers representing greater light-stopping ability.

The split neutral-density filter either graduates density from the top to the middle or has a single-density coating from the top to the middle of the glass. These filters are often used to block light from the sky while admitting all the light from the ground. They are useful for scenes with very bright sky, as they balance the amount of light from the two brightness areas. Not every landscape offers a neat separation or horizon line, so these filters are handy only under a specific set of shooting circumstances.

Lens-protecting filters are colorless and do not affect the intensity of light passing through the lens. Common filters of this type are referred to as UV or skylight 1A. They cut down the effect of ultraviolet light in daylight scenes and are useful for reducing some of the blue cast common in the distance in color landscape scenes. They also protect the front element of the lens and can be left on when the camera is not in use.

Color-correcting filters are used to balance color or to add a slight color cast in a scene. Many landscape photographers use such filters to enhance color for fall or winter scenes. These filters are available in discrete steps of color intensity, expressed as, for example, CC10Y (very light yellow), CC20M (light magenta), or CC80Y (deep yellow). The higher the number, the greater the effect. A light yellow filter, such as a CC10Y, can be used to add an extra touch of warmth to fall leaves or to counteract the blue cast in snow-filled scenes.

Diary:
Photos and Notes

Light inhabits space. But that space is not a void—it is filled with matter that grabs light's energy, that translates it into the shapes, lines, and colors of this world. Those forms and colors are associative—they blend to create our perception of what we see and how we see it. To study light is to observe its dance with matter and to see reflection and transmission, diffusion and diffraction, and all the other ways we describe the play.

Light can be observed by its effects—how it touches and reveals rocks and trees, and even the atmosphere. It changes as the sun shifts in the sky, as clouds form and disperse throughout the day and night. The moments we choose to photograph are those in which there is a coincidence of light and matter that expresses something within us, some kernel of perception that is amazed and amused by the wonder of it all.

If we attempt to give our pictures captions, we often must reach beyond locale or specimen, aperture and shutter speed. We should attempt to reach into that space where the mind delights in color, contrast, and edges and where shadows are always mysterious, playful things. The dazzle on the surface of water is often reason enough for being there.

To express all this in mechanistic terms—in aperture, shutter speed, and how metering was accomplished—is too often a reduction of the moment and a seeming denial of the miraculousness of it all. As one who writes about "writing with light," I find this contradiction all too evident. The only rationale for this approach is that to record these moments with any degree of success, I must deal with such matters. It is, however, the age-old contradiction of what occurs when spirit becomes flesh, when how and why become confused, and when science attempts to explain everything at the expense of the "aah."

For photographers, that dilemma can easily be resolved—just put down the camera, enjoy the moment, and forget about holding on to what is at best a tentative passage of sparkling light and color. This is something I've tried to do more and more as time goes on. But there is still a desire for expression, to say, "Hey, look at what I see." We justify our vision and fulfill our desire to share by attempting to capture those special moments. Only a complete cynic would say that there is nothing worth taking in and giving back again.

All visual artists share in a process that takes the world in, runs it through their emotions and thoughts, and then forms a manifestation of that process with a painting, drawing, or photograph. What makes photography unique is that it deals first with what is directly in front of the photographer—it is primarily an acquisition of some external reality, albeit viewed through the abstraction of camera, lens, and film.

True, the photograph is a record that can be altered through processing and printing techniques and is always open to interpretation after the initial exposure is made. But it always begins with a recognition of one special moment in the continuum of what is, holds on to a visual expression of what was, and can be changed through an interpretive process into what could be.

Within that process, the eye begins to train itself to see, and the photographer in us begins to hone that vision to the rigors of the craft. The aim, it seems to me, is to form some coherence about the world. Sorting through this rush of energy we call life is quite a bit of work unto itself; tagging certain moments as meaningful by making an image is in some ways a refinement of that work, especially when the process includes some stance or attitude about what is being expressed.

There are plenty of subjects and scenes to photograph—as many as there are people,

rocks, trees, clouds, and rainbows in the sky. But given some thought, photographs can evoke more than just memories of standing in one place at one time: They can speak of the coolness of the breeze, of the searing heat of the desert sun, of the lovely illusions of light and matter dancing, that so entranced you at the time. Or they can be allusions to change, to the nature of life, to the brief moments we stood on this earth and bathed in its glories.

All this is difficult to express in words. That's where photographs come in—they allow us to share with all who will see just what we've seen. And even if there are few who will take part in that sharing with you, take heart that the process in which you are engaged is, like any form of art and expression, a path to opening up, to keeping in touch with an essential aspect of being alive.

Awareness of light is a big part of what photography offers. An expressive picture is often just a by-product, though for me it's often the icing on the cake, the culmination of a series of thoughts and ideas that leads to a visual expression.

With that in mind, I'll close this book with a few photographs and accompanying notes. The notes describe part of the process and some of the associations I have with the photos. The technical notes are offered more in the spirit of showing you a process of making photographs than from a need for you to know the details of aperture and shutter speed.

Each of your photographs may have similar tales to tell. Take the time to tell them and to explore your own way of seeing. In each of us waits a child who is still amazed by the wonder of this world. In each of us is the potential to open up more to its glory. Use your photography as one of the ways to explore this path. Let light help you tell your story.

Photographers draw their visual inspiration from many sources. There are many photographers worthy of study for their amazing depictions of natural light, including legacy names such as Stieglitz, Adams, Weston, Porter, and O'Sullivan, and modern practitioners such as Kenna and Sexton. But one should also look beyond photography to painters and spend time with O'Keeffe, Renoir, Monet, and certainly Van Gogh. Each of these artists gives us hints on how to see light and express it in our own work.

The first time you see a Van Gogh, you may be absolutely stunned by his vision. Despite a tortured life and complete lack of commercial success, he went into the field with his paints, brush, and canvas and returned with work that continues to be a revelation of the energy that surrounds us.

The association of Van Gogh and sunflowers prompted this photograph and the journey that led to its creation. My wife Grace and I were lucky enough to spend some time in Provence, in southern France, where Van Gogh worked in the last years of his life.

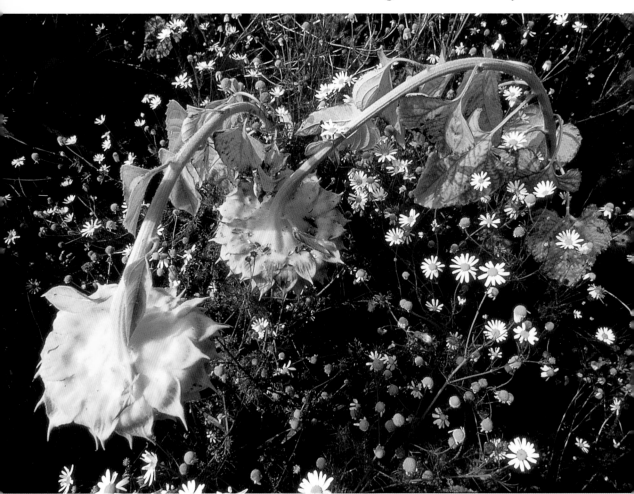

Homage to Van Gogh PHOTO BY GRACE SCHAUB

Part of our journey was to retrace his steps and to stand where he labored with his paints. Our itinerary was aided greatly by a visit to the Foundation Vincent Van Gogh on Rue du Grande Prieuré in Arles. After a few days of planned visits, we began to wander, taking side roads and getting lost among the small villages and surrounding hills.

We were determined to find a field of sunflowers—to us, the ultimate Van Gogh reference. It was late in the afternoon when we came upon a small valley filled with glorious blooms. It was mid-autumn, and many of the seed-laden plants had bowed their heads toward the ground. The light of Provence that late afternoon was blessed with a diffused moisture, yielding a golden softness that makes the area such a playground for the eyes. It was under that light that we began to photograph.

We wandered among the rows, and what from a distance had been a great patch of gold became an endless variety of individual groups of color and form. While the beaming face of the sunflower is unequaled in energy—the very embodiment of the prime source of light from which the plant derives its name—the groupings of bowed heads seemed more truly evocative of Van Gogh than the shining face of the flower.

This grouping is surrounded by small white flowers—asters, I think—that seem like stars twinkling in some Van Gogh night. The arched backs of the sunflowers are like tendons struggling in a failed attempt to lift their faces to the sky. Their pregnancy with seed brings them back toward the earth.

This photograph was made by Grace with a 24mm lens, used to emphasize the curvature and stretch of the plant. A narrow aperture of f/16 was chosen to maintain sharpness throughout the frame. The sharpness was checked by engaging the camera's depth-of-field preview button. Exposure was key to getting the effect of the sunflowers and "stars" shining against a darker field. The camera, a Nikon F3, offers only center-weighted averaging metering, so it was brought close to the bowed head of the sunflower in the foreground for a reading. To add some brightness, exposure was compensated plus one-half stop by moving the aperture setting on the lens a half click between f/11 and f/16. (Modern autoexposure cameras allow you to do this by using the plus or minus auto compensation dial and setting +0.5 EV.) Then a background reading was made; it was f/4 in the darker area. This spread of brightness values (contrast) between the set aperture and the background assured that the background would be darker than it appeared to the eye. After the readings were made, the scene was recomposed. The contrast between the foreground and background and the brightness of the principal subjects in the dazzling light created the desired effect.

This photograph was made way back in 1971, a year or so after I first picked up a camera. I was on a solo camping trip in the Laurentian Hills in Canada, a journey that took me along the Gaspé Peninsula, down the coast to Nova Scotia, and back home through Maine. It was a lonely trip, and I filled my days with long drives and photographic forays up trailheads along the side of the road.

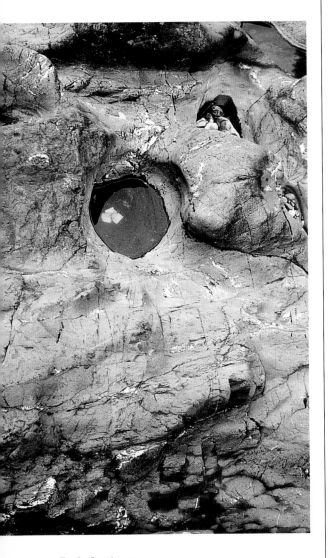

Early Instincts

One evening I camped along a streambed, a worn slate and shale surface made slippery smooth by ancient glaciers and centuries of flowing water. As I took a long walk before bedding down in the late, far-north sunset, I began to see shapes and forms, figures and faces emerge from the rock. Perhaps these figures were companions to my loneliness—perhaps they were spirits that inhabited those woods, awaiting discovery by my seeking eye.

In those days, I used to literally walk around with the camera to my eye, a sort of training that helped me see within that rectangular frame. I would stand in a spot in which I somehow felt a photograph residing and scan the scene until something in my mind clicked. This didn't always result in good pictures, but it did help me begin to see with a camera eye.

Such was the case with this photograph, where the rocks appeared to form a hermit looking out from a small cave niched in the rocks. The photograph was made looking straight down, but I see it as looking up at an escarpment from below. That hermit made me consider myself on the trip; having books of Gary Snyder poems and Zen koans along probably influenced the view.

Technically, it isn't a great shot. The light is flat, as this was in a deeply shaded valley, and the film is beginning to show the ravages of time. But it has meaning for me now, as it did then, and always reminds me of how I began to see with a camera eye. That seeking of spirits in nature is a constant theme within my work, one that opens my eyes to the energy and potential around me.

To consider the sky is a childish thing in the best sense of the word. When we called out shapes and forms as clouds passed by, we began to develop our imagination and started out on a journey that sought some magical contact with the world. To photograph the sky now is to continue that process and to seek clues about the nature of light and how it graces the world.

We often see the sky as a backdrop, as a convenient context to a landscape that adds visual drama or contrast to the scene. But the sky itself is certainly worthy of study, as it teaches us about the many moods, colors, and intensities of light that have such a profound effect on the scenes we photograph. It undergoes constant change and is filled with an infinite range of color and tone.

Photographing the sky above has historical precedents—Ralph Steiner's "In Search of Clouds" and Stieglitz's "Equivalents" are classics that should be considered. Indeed, Stieglitz considered his cloud photography as perhaps the purest and most honest he ever made. Now, when I look at some of Ansel Adams's landscapes, I often think of the subject on the ground as peripheral to a glorious depiction of the sky.

When the sky is filled with ranges of color and light, when the atmosphere displays the spectrum at sunset or on dramatically stormy days, color film seems the obvious choice. I'm rarely tempted to photograph a rainbow in black and white or to lose out on the nuances of color by using a high-speed, high-contrast color film. But I also find myself drawn to photographing the sky in black and white, especially when storm clouds build and there is a range of texture and tonality—the true realm of black and white. Such sky can display the full range of the gray scale and does so with infinite variety throughout the day. For all these reasons, the sky can be a prime subject for consideration of both the photographic medium and the glory of light.

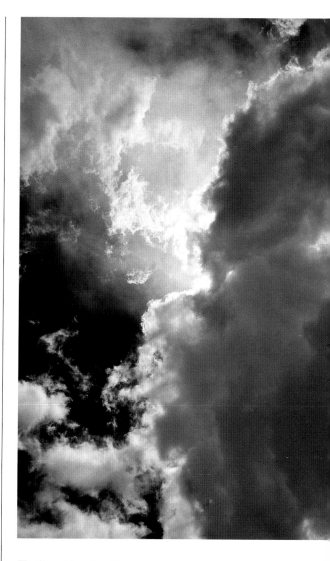

To Consider the Sky

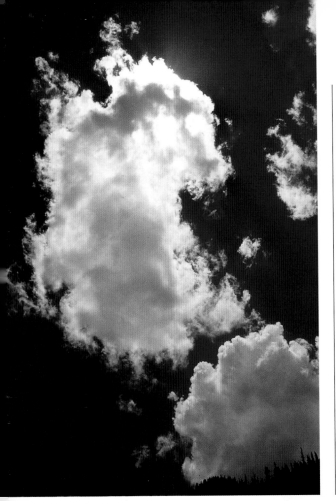

August in New Mexico, and indeed much of the American Southwest, is often called the monsoon season. Unlike the rest of the year, it rains. But that rain is accompanied by huge thunderheads, veils of rain that seem to walk across the plains, and deep, dark clouds rimmed by silvery light. While this drama can be captured with an unfiltered lens, I find that the best results are obtained on black-and-white film when using a color filter over the lens. Because the filter blocks the complementary or opposite color, a yellow, orange, or red filter is best for increasing sky contrast. With color film, I often rely on a polarizing filter, which allows me to alter the tonal relationship of blue sky and clouds within the scene. I can preview these effects right in my viewfinder.

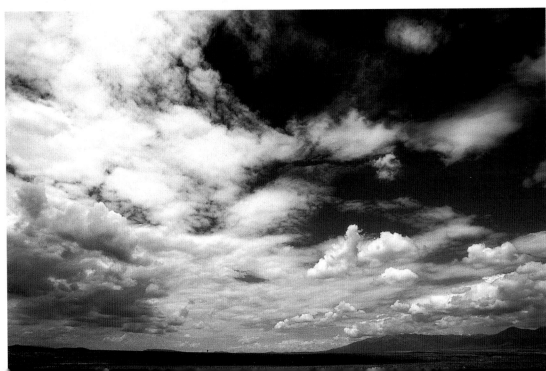

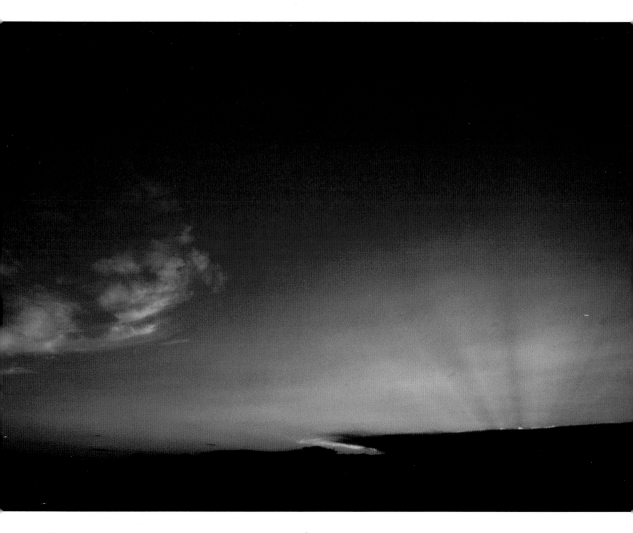

If you're working with a camera with TTL metering, the exposure system will compensate for the darkening effect of the filter. When using a red filter with black-and-white film, however, I usually add a stop of exposure to ensure against underexposure. Even if the negative becomes overexposed, it can be corrected later when prints are made. Adding extra exposure guarantees that every nuance and tone will be recorded on film.

I was raised in the eastern United States—New York City and environs, to be exact—and while I certainly had seen bright sandstone and varicolored rock, my impression of rock and soil had been that of deep loam and the blue shades of shale, schist, and slate. The mountains here are old, and stray rocks from the Canadian shield carried down by ancient glaciers fill the fields and hills.

The first time I ventured west, in my early twenties, I was overwhelmed by the red soil and the deep magenta, red, and yellow rocks of canyon country. The younger mountains and huge upthrusts, etched deep by meandering rivers and peppered with deep black volcanic rock, blew my mind. Here were new colors and forms raised to even higher levels of energy by shafts of sun that in high altitudes caused all to shimmer in the late-afternoon light.

As I continued to explore the area, I was entranced by the high, bright light of the desert plateaus and the immense tract of the Great Basin. It is a light that during the day opens shadows and reveals every detail in the multicolored, striated rock; later in the day, its intensity creates deep shadows that etch the edge of every form. The amazing range of color and tone in the uplifted strata and the shards of larger formations that lay splintered on vibrant soil became a major attraction for my eyes. The combination of revelatory light and a world that is unfamiliar can open one's eyes to possibilities of new ways to contemplate color and design.

The harshness of the environment further heightens the desert's beauty. Seeds find a handful of soil in the niche of a rock and grab hold. They catch some spare rain and begin to spread their roots, feeding, as it were, off the rock that serves as home. They stake their claim and make their stand. To me, there is nothing more beautiful than a desert flower. It is life asserting

itself under the harshest conditions, creating a feast for the eyes amid the deprivation. Such is the creative spirit and the will to express.

It is also why I walk so tenderly among the life of the desert. While tenacious, that life is tentative, and years of struggle can be destroyed with a casual, unthinking step.

Desert Pastels

101

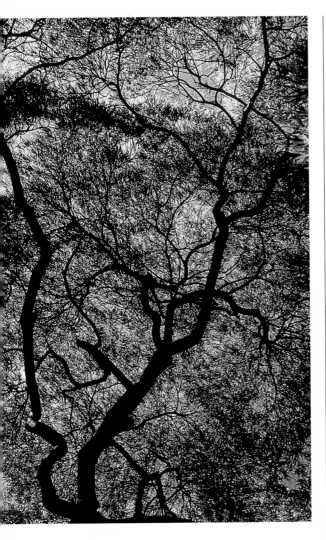

Looking Up

Light is always changing, offering a constant interplay of color and shape. All of these changes are going on all around us all the time. The place we choose to stand and observe these changes—our vantage point, or point of view—is key to exploring light effects and fully realizing their potential for our photographs.

Not far from where I live is an arboretum, a state-run tree garden planted around the manor house of some rich guy who couldn't afford the taxes. The variety of trees and the progression of budding, flowering, and changes throughout the seasons is quite amazing. The place has become a source for many a day's photographic pleasures. In a field not far from the house is a grove of Japanese maples, a deciduous bonsai grouping that has been lovingly cultivated and pruned by generations of gardeners. The trees stand no more than 6 feet high, yet the twists and turns of the branches and the delicate foliage combine to create fascinating light and form play. Each time I visit that arboretum, I usually end up on my back gazing up through those trees. I appreciate the rest but also find it a visually exciting place to hang out. It's become one of those places I return to again and again. I have photographed from this vantage point many times and always come away with a different pattern of light, color, and form from each session and in each season.

These photographs were made in early spring and late fall. I used a 24mm lens to expand the space and exaggerate my distance from the branches, which were only a few feet away, and thus the size of the tree. I metered off the brighter part of the scene, ensuring both rich color saturation in the leaves and the creation of a silhouette out of the limbs of the tree. The combination of twisted forms and bright, sunny light is just what I had in mind each time.

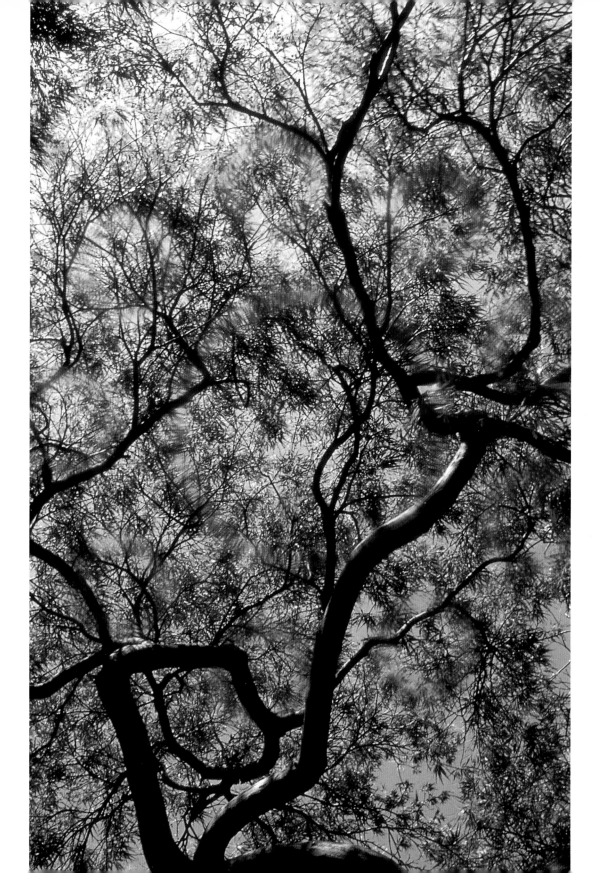

Exposure technique is what allows us to manipulate light—to control color saturation and enhance contrast. The aim of any technique is to express a personal vision of a time and place beyond what a purely objective camera's exposure system might deliver. This expressiveness might incorporate a hiding and revealing—a selection of details to highlight, and perhaps to obscure, for graphic or pictorial ends. The process of selection involves first seeing the potential in the frame, then making considered exposure decisions about how that potential can be realized.

On a walk in the woods in New York's Catskill Mountains in late fall, I came across some low branches lit by directional light. Many possibilities presented themselves, and choosing one or another composition occupied my time. What attracted me in the first place, however, was the potential for light play. The mottled light kept shifting in the breeze and offering new plays of light and shadow with every touch of the wind.

I chose the framing here based on the descending rhythm of light. The flow of the branches and leaves culminated in the brighter, larger cluster at the base of the frame. I knew that I wanted to accentuate the dappled light and use its play for a bright foreground against a dark background. I wanted the background to hold some texture, more for context than for detail.

To make an exposure reading, I filled the viewfinder with the bright cluster of leaves at the base. What in nature was quite bright then became a middle value on the film's recording scale—an interpretive exposure that darkened the scene overall and resulted in more color saturation in the leaves and a darker background. In real life, the tree bark was filled with detail and the leaves were quite bright.

This type of exposure decision-making is key to in-camera interpretation. Although with negative film you can reinterpret the color and light later, when a print is made, seeing color, light, and form is not always a retrospective matter. To see it when you're there and to be able to frame and expose with an interpretive, expressive eye is one of the most artistically rewarding and exciting aspects of the photographic experience.

Selective Exposure

Glimmering Light

Zion National Park in Utah is one of the most glorious places on earth. High mesas, craggy cliffs, and the Virgin River cutting through the valley make it a photographer's paradise. The towering cliffs act as huge reservoirs, creating misty waterfalls and sweeping funnels of water that make the valley floor an oasis in the desert. When water hits the red rock, it creates even greater color richness; green moss and lichen add to the mix.

This photograph was made at the top of the Emerald Pool trail. The pool is usually fed by a misty spray that descends from above. The rock face is lit by reflections from the pool as it catches the sun. The brightness value shown here is very close to that in the original scene.

To maintain that character of light, it was necessary to first read off the upper portion of the wall, and then compensate exposure on slide film by minus one stop. If I had exposed at the camera-recommended reading, the rock face would have come out much lighter, and the glimmering character of the light might have been lost.

Sometimes the dam breaks open, and torrents of water replace the misty waterfalls. Ten minutes after this photograph was made, as we started back down the trail, we heard a deep rumbling that foretold more than thunder. Having been in desert areas before, we knew that volumes of water mean flash floods. We got to higher ground and watched in awe as a wall of water tumbled down the trail, carrying everything loose before it.

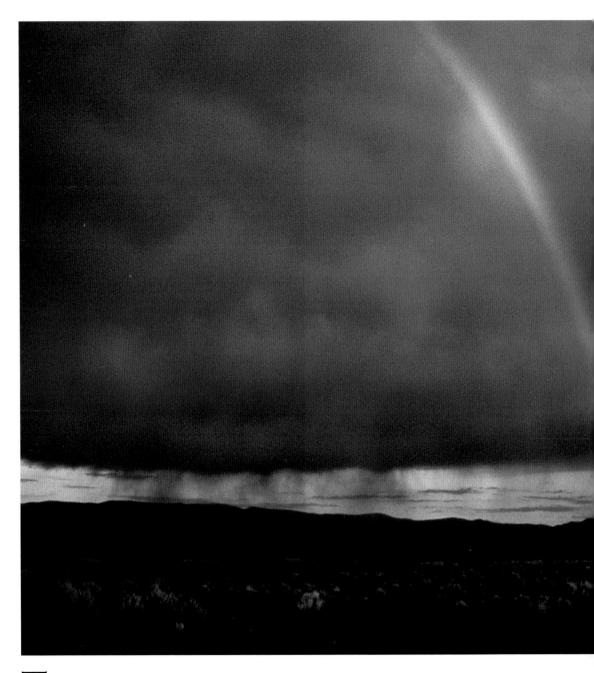

There are a few places where encounters with glorious light are almost inevitable. Where the ocean meets the shore, where mountains rise up out of the plains, where great banks of fog form in valleys—these are the transitional places that offer the potential for powerful photographs. One such place is Taos, New Mexico, and environs. The Sangre de Cristo (Blood of Christ) Mountains got their name from the red glow

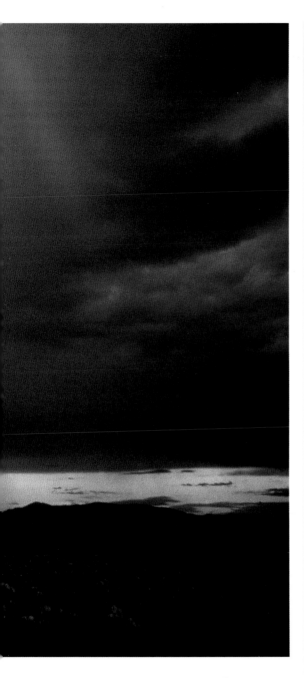

Double Rainbow, Taos, New Mexico PHOTO BY GRACE SCHAUB

mer afternoons, however, it's likely that you'll experience a thunderstorm. The sky and clouds build to a crescendo, culminating in a downpour and dramatic lightning displays that dance around the sky as far as the eye can see.

When these storms hit, sensible folks head indoors or under a veranda, but many photographers immediately head for a vantage point north of town near the spectacular Rio Grande Gorge bridge. Although standing on an iron bridge during a lightning storm is not recommended, there are plenty of solid earth places to stand and photograph. The rain can be intermittent, or may not fall close to your location at all, allowing for plenty of spectacular photographs.

The storms are rewarding enough, but the real payoff is when the sky begins to clear. That's when rainbows start popping up—full arches and partial shards, like random prisms floating through the air. Double rainbows, though not common, are a featured event.

Because a rainbow is best seen against a dark background, it should be treated with the same technique used for any bright subject with a dark field dominance behind it— that is, make a general reading from the sky, and compensate by subtracting exposure from the camera-recommended reading. This is also a good time to try out bracketing. Expose for a range of minus one-half to minus one and a half stops with slide film, and minus one to minus two stops with color negative film, using half-stop steps in between. Bracketing ensures that just the right light will be captured on film and is a fail-safe measure made for such unique lighting events.

they often exhibit at sunset, an effect caused by the straight shot of light hitting their face from hundreds of miles west.

The area is not generally stormy, although a good deal of wind can blow. During sum-

I remember, as a kid, standing in my back-yard and doing what kids do in backyards, when I was suddenly distracted by a sound. I looked up and noticed that it was raining in the yard next door but not a drop was falling on my head. That went on for a number of seconds, and I remember the feeling of sus-pension, of standing on the edge of some-thing that I thought inevitable but that had not yet occurred. Perhaps the rain would just sit there, I thought, or it might move away in the other direction. When it began to fall on me, I was startled, as it didn't come closer inch by inch but seemed to leap over me into the yard beyond and fill my entire world with rain. That awakening made me conscious, at least in retrospect, of the unique quality of every moment, of the sense of suspension when we stand on any edge, awaiting the next stage of reality to come our way, and that the reality we see across that edge is capricious, one that could go either way.

Visual edges create the same effect. They are the borders between light and shadow, the contours where mist and direct light accompany one another, the break between sharpness and unsharpness in a scene.

Such is the effect of this scene made near the Chama River in northern New Mexico. The sun and clouds were playing that day— one moment it was light, another dark; as was the rain—one moment a downpour, the next a quiet calm. The light moved quickly, illuminating moist fields of sunflowers with direct, hard rays, then obscuring all in a deep shadow. It changed by the moment and in every direction.

This photograph is but one moment in that continuum and shows the divisions of light that occurred that afternoon. The fore-ground is bright and aglow; the middle ground is obscured by a dark cloud; and the background is covered in the blue mist formed by aerial perspective.

The composition is intentional but arbi-trary, and it cuts the scene into horizontal

zones. The exposure reading was biased toward the bright flowers. The reading was made by filling the viewfinder with two-thirds flowers and one-third dark surround, then the camera was shifted for recompos-ing the photo as you see it here.

If the camera had been pointed in another

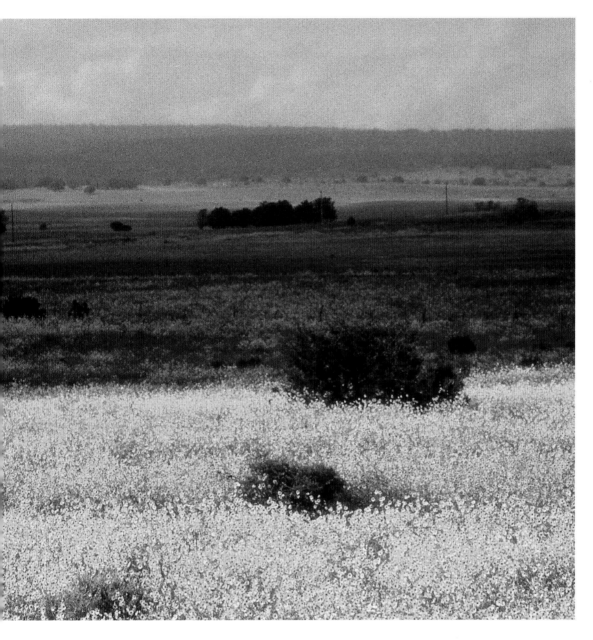

direction, to the left or right, or if a different exposure decision had been made, the effect would have been totally changed. The thing about edges is that you can move back, to the side, or jump right over them—or you can wait until the edge moves and envelops you in its light.

Edge-of-Light Effects PHOTO BY GRACE SCHAUB

The light from above undergoes numerous changes when it becomes involved with our world. We see color and brightness due to a host of factors that interact with our eyes and minds. We can photograph with the intent of documenting a moment and defining a specific place and time. Or we can use the elements before us to create another level of reality, one that attempts to go beyond what *is* to express a notion of pure color and form. The ability to abstract is often thought to be the realm of the artist who uses pastel or brush, but in truth, it is also well within the reach of the photographer.

One way to explore this realm is through the use of defocusing techniques. When we blur reality, we make a subject or scene unrecognizable as form and deconstruct it to pure color and light. This may seem antiphotographic to some, but given that photography is a way to open our eyes, it seems perfectly legal.

This approach is often simply a matter of looking through the viewfinder and turning the lens until the subject is unsharp. It's not a complicated technique. If you'd like to try it, start by selecting a subject that lends itself to this technique. Work with a moderate telephoto lens—between 110 and 210mm is usually best. The longer the focal length of the lens, the greater the ability to defocus at a variety of working distances. Open the aperture to the widest possible setting—the maximum aperture—so that what you see in the viewfinder in terms of depth of field is exactly what you'll get on film. You can use narrower apertures if necessary, but use depth-of-field preview to ensure that what you think will be unsharp is actually unsharp on film.

When you see a scene with potential, raise the viewfinder to your eye and begin to unsharpen the image by turning the lens in manual focus mode. You need not rack the lens all the way out. Turn the lens slowly until whatever you're seeking begins to happen in the finder. Here, the blossoms at the edge of a pond seem to burst into circles of colored light. The edges of the stems and branches in the background are softened and painted with a broad brush rather than with the pencil of nature.

Light Impressions PHOTO BY GRACE SCHAUB

The eye is active; it adapts to bright and dark and near and far in a blink. It encompasses all to form a cohesive image of the world. It can read time on a wristwatch, and then shift immediately and see detail in the farthest hills. It can see each vein on the brightest leaf in the forest, and then notice a rabbit hiding in the densest growth.

Camera and film can only emulate a brief moment in this continuum of change. The illusion of depth of field is what allows us to encompass subjects at different distances in a zone of sharpness; we have one exposure to incorporate the range of brightness values in the scene. This is the wonder, and at times the challenge, of photography—to attempt to express on film what the eye sees.

This photograph of aspen trees high in the New Mexico mountains is a statement on that range of light. It's usually not a good idea to include the sun within the frame— the danger of flare and potential of excessive underexposure of certain subjects is too great. But here the sun is split into a starburst, partly because it is diffracted around the branch of a tree and partly because of luck.

The high contrast of this scene makes it impossible to record details in both the bright and the dark areas—something has to be sacrificed. But the range of light is widened by the intercession of the leaves. They catch the light of the sun, absorb some of it, and transmit their own brilliance and color back to the camera. Thus, the energy of light is transformed by matter, and in that transformation we see the potential of that pure light when it mixes with the world around us.

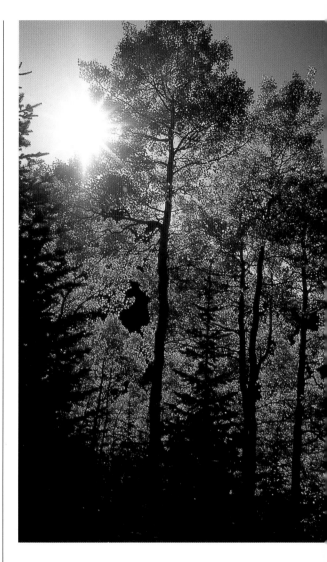

The Range of Light PHOTO BY GRACE SCHAUB

111

The Film Palette PHOTOS BY GRACE SCHAUB

Every time we make a photograph, we translate light onto film. Just as a painter might choose to work in oil or acrylic, pastel or watercolor, the medium of film has a distinct palette that can have a major influence on how a scene is rendered. The choice of color or black and white, of course, has a profound effect on how we see and what aspects of the scene we record.

Every color film choice we make can have an effect on the way color is rendered. Films of different brands and speeds offer various color saturation and contrast effects and may even render the same color in different ways. In general, however, most color films deliver images that are close enough to our memory of the subject or scene. One example of when the medium might overwhelm the subject is when very fast, or high-speed, films are used. These films can bring a very distinctive look to an image.

Because film speed is in large part determined by the size of the light-sensitive silver halide grains in the emulsion, very fast films

tend to have noticeable grain patterns when enlarged. These large grains can at times break up the image into gritty particles, an effect that is enhanced when the film is push-processed and contrast is increased. The effect on color can be equally strong, with some colors actually breaking down into their components in large masses of tone. In essence, high-speed films alter light by creating a unique canvas and paint.

A number of years ago, Grace was commissioned by Scotch Photo to make a series of images using their ISO 1000 color slide film. She chose close-up florals as her subject and produced an amazing set of photographs that matched color, light, and palette in perfect synchronicity. Alas, this wonderful film is no longer on the market. We are left with what are called push films, those rated at ISO 400 that can be push-processed to speeds as high as EI 3200. While grainy when pushed, they lack the soft, impressionistic feel of Scotch 1000.

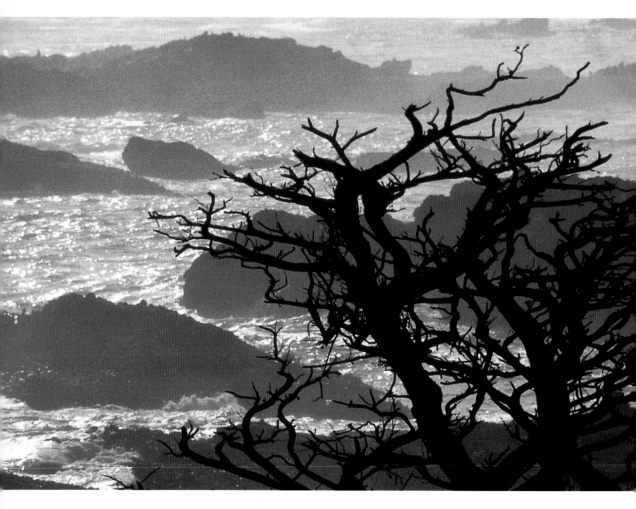

Pilgrimages

Apilgrimage is a journey that often teaches as much in the making of the trip as in reaching the final destination. It is taken with a higher purpose in mind and touches something outside of ordinary experience. It is, above all, a process of discovery. Much like art, it can help reveal what is real and true about our lives.

For many artists, that pilgrimage is to places where their mentors worked, a locale or even an intellectual space frequented by those who have inspired them. The journey becomes a way to understand that legacy and to relate to whatever energy touched those we most admire. For some, that means walking the streets of Florence or wandering through Provence; for others, it may mean hiking in the Sierras or strolling along a particular beach. Sit on the plaza in Ranchos de Taos, New Mexico, and you'll see photographers popping in and out of their cars all day long, attempting to recap-

ture the spirit of photographs of the church made famous by Strand and Adams. Or you can watch the pilgrims drive up and down Route 84 north of Espanola, seeking the vantage point from which Adams made his famous "Moonrise over Hernandez."

One pilgrimage I made was to Point Lobos, outside of Carmel, California. This was where Edward Weston made photographs that have always inspired me, where his intimate association of light and tone helped forge in me the determination to pursue photography as an expressive medium. For me, his vision is both boldly naturalistic and highly abstract, and reveals to me the true essence of what photography can offer.

The trip did not disappoint. The light along the shore changed from clear and crisp during the day to a haze that drifted in as the day waned. We spent the day clambering around the cliffs and walking shoeless in the tidal pools. As I walked and photographed, I got a glimpse into how Weston's photographs could combine intimacy and grandeur, and why some locales are so closely tied with the process of developing a photographic eye.

It was one of those days of photography that make you eager to see the results, that breathe fresh air into a receptive mind. It was also a day in which the photographs themselves became reminders of the events and thoughts that occurred, of an experience that stays with you long after it's over.

The study of others' work and the connection you find with certain photographers or artists can lead you to such places. When you arrive, don't feel that you have to emulate their subjects or scenes or that you have to put your tripod on the exact spot where they worked. Do keep open to the emotions and light they revealed, and allow yourself to be bathed in that same glow. That way, whatever energy is present may begin to touch you, and you'll take away more than just photographic evidence that you were there.

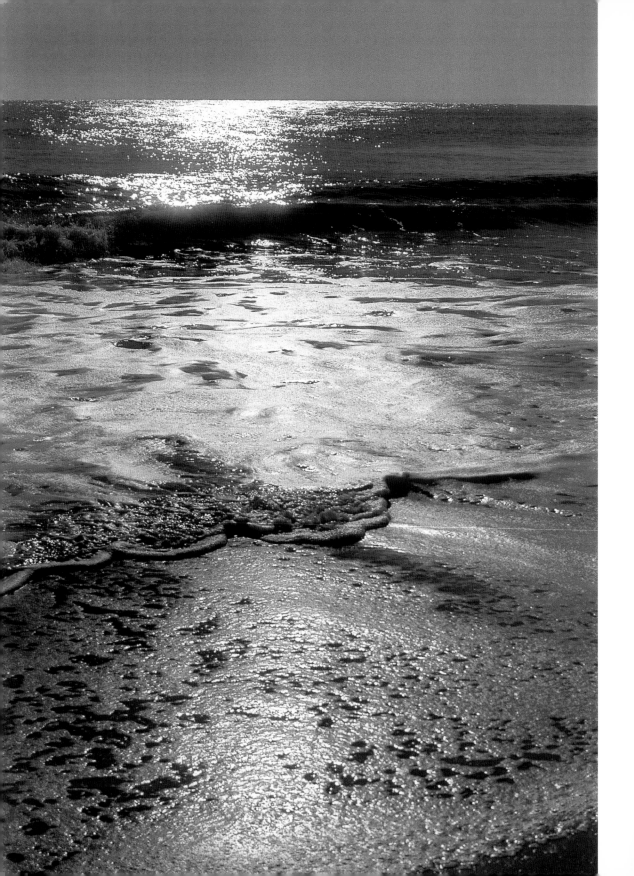